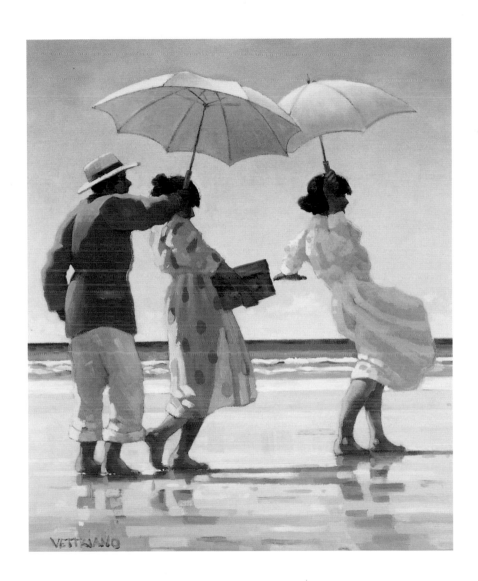

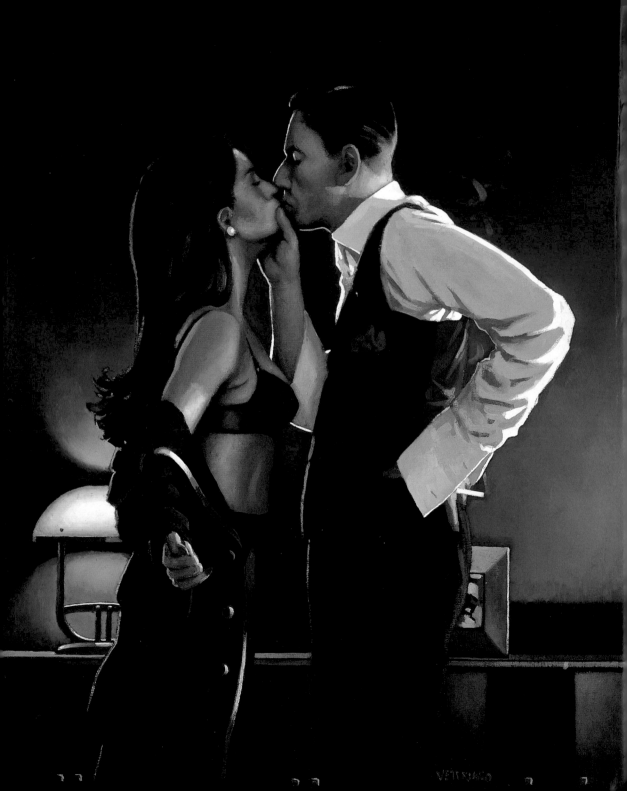

JACK VETTRIANO

TEXT BY ANTHONY QUINN

PAVILION

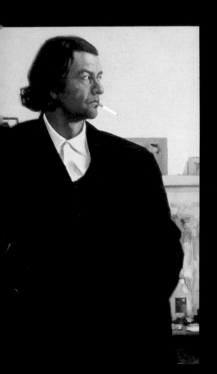

First published in Great Britain in 2004 by
PAVILION BOOKS
10 Southcombe Street
London W14 0RA

An imprint of Anova Books Company Ltd

This edition published in Great Britain in 2006

Designed by Bernard Higton

A CIP catalogue record for this book is available from
the British Library.

ISBN: 978 1 862057 24 1

Text set in Palatino
Colour origination by Mission Productions Ltd
Printed and bound by SNP Leefung

10 9 8 7 6 5 4

www.anovabooks.com

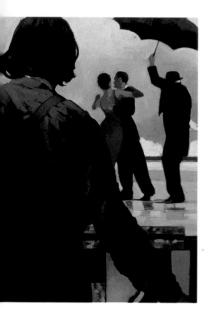

INTRODUCTION

It is an image that has become as recognizable as van Gogh's sunflowers and Monet's water lilies, and in reproduction outsells both of them in Europe and the UK. *The Singing Butler* is the signature painting of Scotland's most popular artist, Jack Vettriano. Beneath lowering skies, a couple in evening dress dance on a beach while, flanking them, a maid and a butler stand in patient attendance with umbrellas held aloft. A wind is up, and droplets of rain presage a storm. The faces of all four figures are either turned away or obscured; there is nothing to indicate how long they have been there, or why the dancers have chosen to waltz out of doors when conditions look so unpromising. We don't know what the butler is singing, though it is not beyond the bounds of possibility that his song, ostensibly a serenade for his master and mistress, is actually intended for his below-stairs companion, the maid. As with so many Vettriano paintings there is a hidden narrative here, but the matter of whos, whys and whens is for us to supply. His enigmatic compositions are a starting-point for a dozen different short stories.

The painting now constitutes a remarkable story in itself. On the evening of 19 April 2004, at Hopetoun House near Edinburgh, Sotheby's offered fourteen Vettriano originals for auction, among them *The Singing Butler*, which was estimated at a price between £150,000 and £200,000. More than five hundred people queued outside the auction room in the hope of getting a seat. Those who gained admission were about to witness history in the making: after fierce bidding the painting was finally sold for a staggering £744,800. The buyer's identity remains unknown, though Sotheby's confirmed that it was a UK-based collector of Scottish art. What is undisputed is the new world record it set for a Scottish painting sold at auction, easily outstripping the previous £520,750 paid in 2001 for Samuel John Peploe's *The Black Bottle*.

More surprises were to follow, as the remaining Vettrianos sold at two or three times their estimated price. By the end of the evening the paintings had fetched nearly £2 million in total.

To gauge the strength of the Vettriano phenomenon one should consider the short history of *The Singing Butler*. Originally exhibited in the Solstice Gallery in 1992, it sold for £3,000 – this after being rejected by the Scottish Arts Council and by the Royal Academy for its summer exhibition. In 1998 the original buyer offered it for sale privately and it was bought for £33,000 by a Fife art collector, Alex Cruickshank. Demand for Vettriano climbed steadily and, in 2003, a small oil study for *The Singing Butler* was sold by Sotheby's for £89,600, at that time the highest price ever paid for his work. The Hopetoun House sale has left that sum a mere speck in the distance and, more significantly, has given a new twist to the continuing argument over Vettriano's worth. Broadly speaking, the art establishment disdains him as populist and unchallenging, and British galleries consistently refuse to acquire any of his works for exhibition. His admirers, on the other hand, couldn't care less about critical opprobrium and continue to buy Vettriano prints, postcards and paraphernalia; collectors' interest, as we now know, has altogether entered another sphere. The day after *The Singing Butler* sale, *The Scotsman* pitched into the debate with an editorial ("Galleries' art bypass") on the hostility of the national galleries to Vettriano, and posed the question once more: "Should the nation's collection include Scotland's most popular artist? The answer is an undoubted yes, if the collection is to be at all representative of Scotland's artistic history, which is its duty."

The paper also ran a feature canvassing different professionals – art experts, painters, curators, writers, even a butler – on what they thought of Vettriano. The reaction was overwhelmingly in his favour, and even those who were ambivalent about his work acknowledged his significance. Guy Peploe, grandson of S.J. Peploe and managing director of the Scottish Gallery in

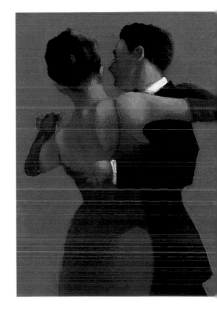

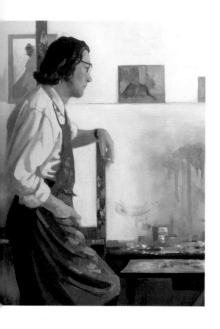

Edinburgh, made it clear he was not a fan yet conceded that a copy of *The Singing Butler* should hang in the National Museum of Scotland as a reflection of current popular taste: "As an image-maker he is a fascinating part of cultural history and can't be ignored." In fact, it is not strictly true that Vettriano is unrepresented in the public domain. Some years ago Carolyn Osborne, a friend of the painter, donated one of her own Vettrianos (a study of *One Moment in Time*) to the Kirkcaldy Museum and Art Gallery. Such was the interest that the gallery managed to arrange a transfer of Vettriano's 1998 show *Between Darkness and Dawn* from the Portland Gallery in London (where he has been exhibited since 1994). The study, and another self-portrait donated by the painter, can be seen in Kirkcaldy Museum today.

The local boy has indeed made good. Vettriano would be the first to acknowledge the continuing significance of his early years in the coal towns and villages of Methilhill, Leven and Kirkcaldy. Here he was raised in the shadow of the collieries where his father worked as a miner. "All roads lead back to where I grew up", he has said, and though this stretch of Fife was hardly a playground of sophistication, it did at least have two ballrooms, the Raith and the Burma: their faded glamour hooked the young Vettriano, as did the women who frequented them in their high heels, crimson lipstick and beehive hair styles. He didn't know it at the time, but he was storing away memories of his nights on the town – Art Deco balconies, the smell of perfume and cigarettes, black ties on white shirts – which his imagination would, eventually, transfigure on canvas. Before that, long and restless years lay ahead.

From a young age Vettriano liked to draw, and he found a decent supply of materials in the six-by-four-inch white pads of paper and pencils his grandfather brought home from the betting shop. His early efforts tended to be sketches of "goalmouth incidents and birds' nests". He left school at fifteen, eager to earn a wage, and followed his father down the mines, graduating from

sandbag-filler to engineering apprentice. On his own admission he spent more time skiving and smoking than he did working. He drifted through other jobs in London and Edinburgh, still unsure of what he wanted to do, aside from chasing women. The turning-point came when a girlfriend, Ruth McIntosh, gave him a set of poster paints on his twenty-second birthday. Already able to sketch, he began borrowing library books to teach himself the rudiments of painting, though he had to make do with his back bedroom rather than the "studio" which the manuals recommended. He would discover that most of the things worth knowing about paint he had to teach himself.

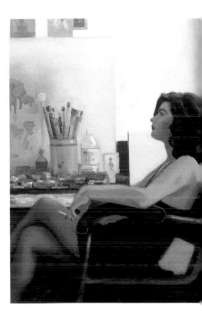

As he learned, he practised copying other paintings, starting with the Impressionists and then moving on to the likes of Picasso and Dalí. He knew he could ape a style, but it didn't satisfy him. He needed a subject. Nonetheless, by 1979 he had accumulated enough material to mount his own exhibition, not in Scotland or London but in the unlikely, far-flung climes of Bahrain, where he had secured a job in the personnel department of a management consultant – the latest in a long and varied line of employment. Nobody asked to buy one of the twenty-odd paintings he exhibited, but this didn't bother him unduly: "I was just painting for myself", he recalls. Back in Scotland two years later, he married Gail Cormack from Kirkcaldy and settled down in Glasgow. He began to devote most of his spare time to painting, making a little money from it as he felt his way towards a personal style. The search was now obsessing him: "I didn't want to spend my life copying other people. I knew I had to start thinking about those things that meant something to me." He became introspective and, as he admits, selfish about his time. Friendships took a back seat to his painting, and so too, eventually, did his marriage.

Vettriano doesn't remember which catalyst supplied his "eureka" moment , but at some point in the late 1980s he realized that his subjects had always been in front of him. The first was his lifelong obsession with women,

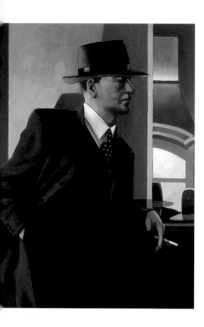

particularly women who liked to dress provocatively – stilettos, silk stockings, a flash of thigh and a vivid lipstick. The second was his romantic-melancholic view of the past, a place of idyllic summer beaches, intimate café society and railway stations straight out of *Brief Encounter* (a title that could describe a whole swathe of Vettriano paintings). The Raith ballroom had by now been converted into a church, and the Burma demolished, but that only encouraged him to romanticize them: their throwback glamour furnished settings for the rituals of courtship and seduction. He decided to fuse these two preoccupations and, by degrees, the first stirrings of the Vettriano style became apparent. He painted a portrait of Gail (*Model in a White Slip*) and another of a dancehall couple framed against an Art Deco pillar (*Saturday Night*), both of which he submitted to the Royal Scottish Academy's summer exhibition of 1988. Both of them were sold within fifteen minutes of the doors opening. He recalls the occasion as "a shot of pure adrenalin": these were the first canvases to which he had properly devoted himself, and they had sold instantly. Who knew what might be in store?

His first artistic triumph was offset by the collapse of his marriage. Gail left him, and he left Kirkcaldy for Edinburgh where he set up a small studio and, for the first time in his life, painted all day. The future was suddenly alive with possibilities. "I went into overdrive, thinking about situations and looking at my own marriage, at how flawed relationships were." He decided to mark a break with his past work, which hitherto had been sold under his family name, Hoggan. From this time he would adopt his mother's maiden name, the rather more stylish-sounding Vettriano. As a result of his success at the RSA exhibition he was soon courted by different galleries in Edinburgh and Newcastle. Without quite understanding how, he was in demand and now had to organize his work schedule accordingly: he more or less abandoned his social life and retreated to his studio, where he might spend twelve hours or more a day painting.

"It's a perfect world I would like to have lived in, but didn't", he says of his paintings, whether they are the nocturnes of bedrooms and ballrooms, the noirish precincts of bars and clubs, or the open-air insouciance of beaches and railway stations. Small wonder that Vettriano's outdoor paintings are likened to the railway posters of the 1930s, an era that spoke of gracious living and glamorous new horizons, when men and women knew how to dress properly: a dark suit and snap brimmed hat for him, a summer dress or a ball gown for her. Perhaps such a world is a chimera, an Arcadia that never existed, but looking at a Vettriano makes you wish it had. Too bad that the critics don't get him, that the national galleries don't want him, and that all but a couple of his paintings remain unavailable to the public gaze.

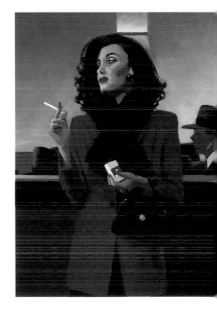

Not that he needs to worry. The last twelve months have been something of an *annus mirabilis* for Vettriano, what with the award of an OBE, an honorary doctorate from St. Andrew's University and – something else to brag about – a *South Bank Show* profile devoted to him. At the Portland Gallery they receive hundreds of inquiries every day about his work, and interest since *The Singing Butler* sale has gone into overdrive. As Tom Hewlett, Vettriano's dealer for the last eleven years, says, "I don't know of any other gallery that enjoys such interest in a single artist." Given the mercurial state of the art market, Vettriano is well aware that popularity is a perishable commodity. Yet the idea of falling out of favour doesn't trouble him, because his own passion for the work is unchanging: "One generation might rubbish me, and because they do the next generation is bound to praise me. You come and go, so there's no telling." The *South Bank Show* profile showcased him as "the people's painter", an epithet whose democratic ring may be considered a rebuke to his critics. But the true strength of Jack Vettriano is that he will be, always and inimitably, his own man.

Anthony Quinn

TALES OF LOVE AND OTHER STORIES
1987 – 1993

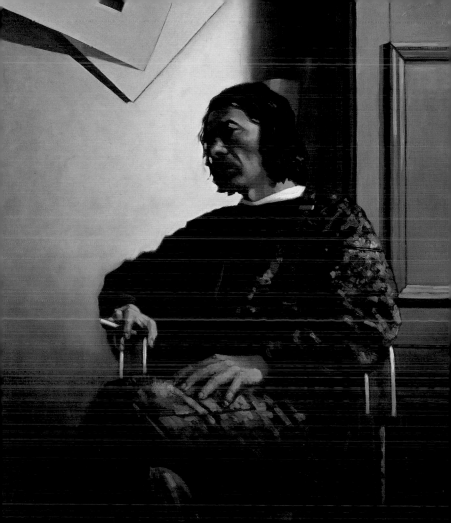

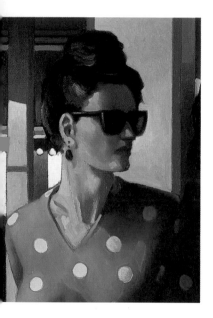

Once Jack Vettriano had sold the first two paintings of his "new" career at the Royal Scottish Academy's summer exhibition in 1988, it unlocked a demon of creativity. He withdrew into solitude, sometimes spending twelve hours a day painting, which was just as well because several galleries were already importuning him for his work. Cannily, he kept most of them at arm's length.

The Solstice Gallery in Edinburgh tried to persuade him to launch a one-man show, but Vettriano was not yet confident enough about his work to face such scrutiny. Instead he agreed to take part in a two-person show, *A Contrast of Styles* (with Joan Renton) at the 1991 Edinburgh Festival. The show, which provided the capital with its first proper look at Jack Vettriano, was an overwhelming occasion. The paintings were snapped up, and any doubts he may have harboured about interest in his work were conclusively laid to rest.

In May of the following year a solo show, *Tales of Love and Other Stories*, opened at the Edinburgh Gallery in Dundas Street, and the art critic W. Gordon Smith, one of Vettriano's earliest champions, wrote an enthusiastic introduction to the catalogue: "Slowly but surely, he becomes the Vettriano he wants to be. If it is a wonder that he has managed to teach himself drawing, perspective, the manipulation of paint in veiled glazes and meaningful shadows, the music of colour and the dramatic focus of compositions, it is even more remarkable that he has evolved such an identifiable personal style."

Remarkable indeed. For a painter who only two years before had been reluctant to exhibit solo these canvases came as a thunderclap. Brooding, enigmatic nocturnes suggested love betrayed or gone bad or, as in *A Kind of Loving*, weirdly transmuted. Here, a man stands in front of a row of mannequins, embracing them with fetishistic reverence. Vettriano recalls the inspiration for it: "I was walking through the Grassmarket one day and looked into this very funky boutique selling these dresses. I went in and asked if I could take photographs of them. They seemed like lovely things to have around." At this time he was living alone, and out of that solitude sprang the

idea of a one-way passion. "Here is a man so involved in his own world that he doesn't have time for relationships, he's not good at them. But he loves to look at the female form, so he keeps these dresses in his home which he now and then takes out to gaze at."

His imagination was stirred in a quite different way when he painted *Queen of the Fan-Dan*, wherein a scarlet-jacketed madam, closely surrounded by her clients, holds forth a candelabra as if it were a devil's fork. Vettriano recalls playing in the fields as a boy and watching the local Teddy boys swagger by; their destination was whispered to be a place called "the Fan-Dan", which he pictured, in his inflamed mind's-eye, as a club "full of women and sex and drinking". Too bad that the place actually turned out to be a garage belonging to somebody's dad, where the only thing to drink was Vimto. As ever, reality fell short of the painter's romantic sensibilities, and years later he decided to put on canvas what he imagined – what he wanted – the Fan Dan to be. "It's a private club, a bit like Muriel Belcher at the Colony Room, the way she used to rule the roost. If she doesn't like you, you don't get in – and she'll tell you she doesn't like you."

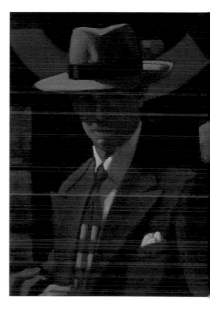

Queen of the Fan-Dan would find an answering echo in *Cleo and the Boys*, one of thirty-seven paintings exhibited in Vettriano's next one-man show, *God's Children*, held in The Mall Galleries in October 1992. Once again, beach scenes alternated with night-time interiors, from the contemplative solitude of *Heartbreak Hotel* to the strangers in a train station in *Angel*, to the seaside idyll of *Mad Dogs*. His love of manipulating shade and light had now been finessed into a trademark. Consider *Evening Racing*, in which men, sombrely attired in hats and overcoats, look intently outwards – one can almost hear the horses thunder past the rails. Only one of the throng turns towards the viewer, the hat-brim veiling his face in shadow. As so often in Vettriano, the hat becomes a form of disguise, a means of shutting out inquiry. His characters like to look, but not all of them like to be looked at.

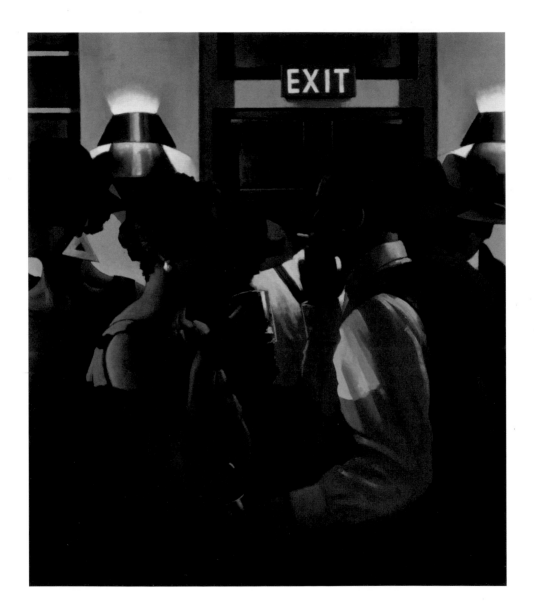

THE CITY CAFÉ

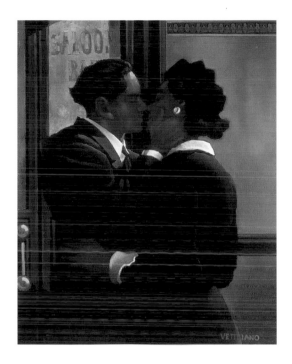

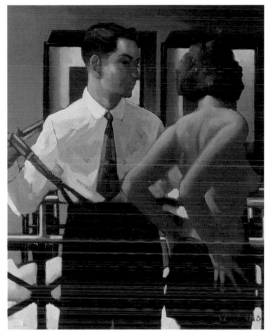

AE FOND KISS

STRANGERS IN THE NIGHT

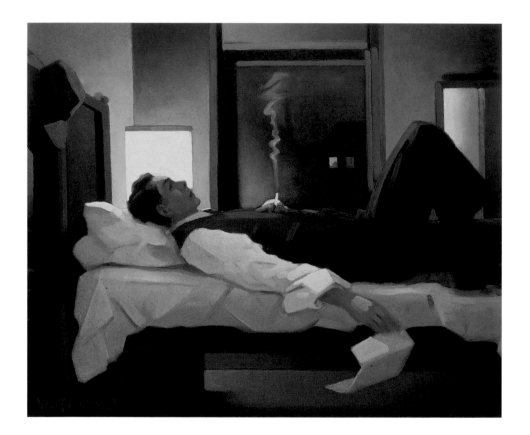

HEARTBREAK HOTEL

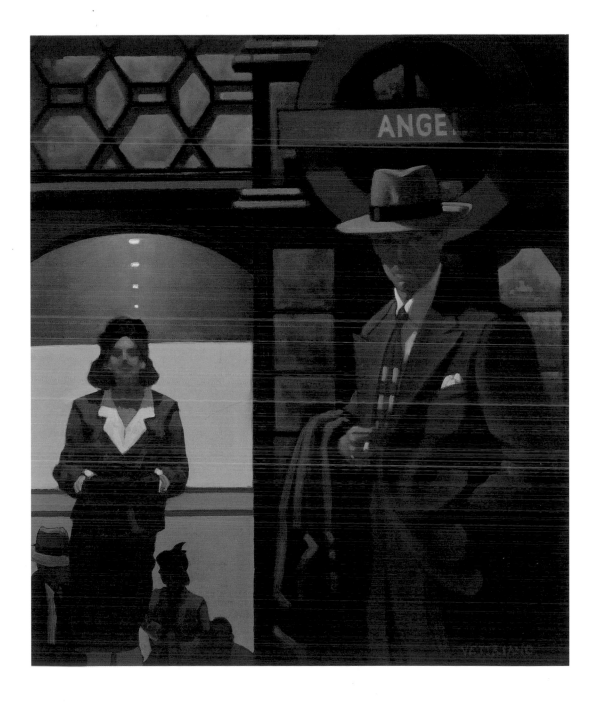

ANGEL

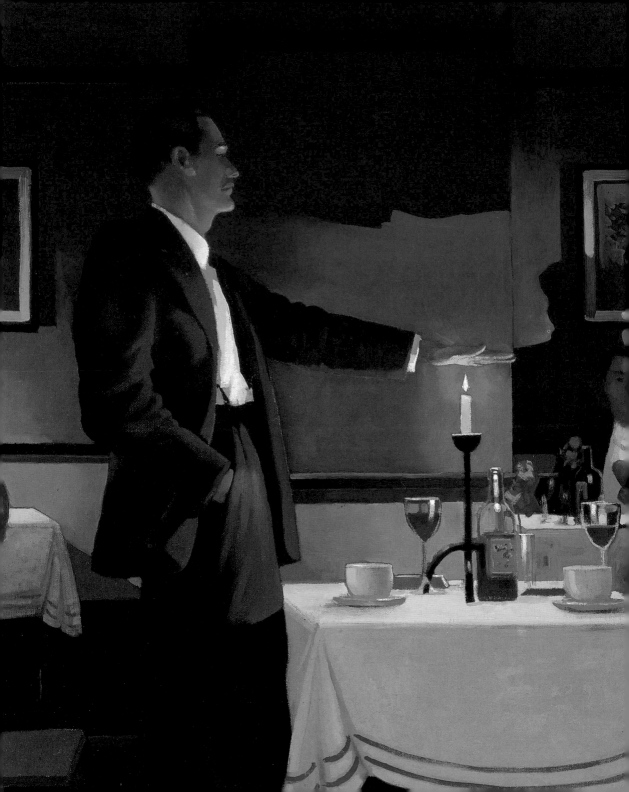

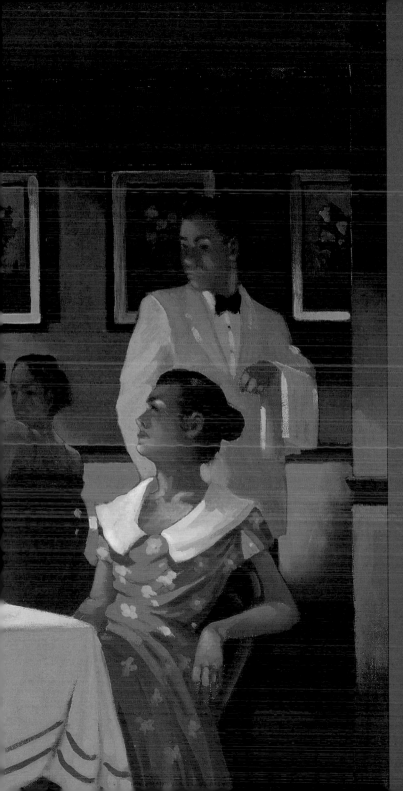

"What attracted me is the narrative quality of his work ... like reading a book, your mind puts together the scene as described by the author ... it enables the viewer to engage with the painting and then develop it."

TOM HEWLETT, PORTLAND GALLERY

A TEST OF TRUE LOVE

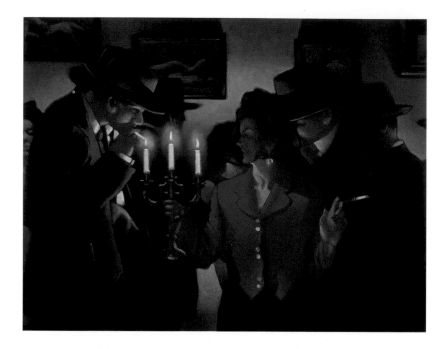

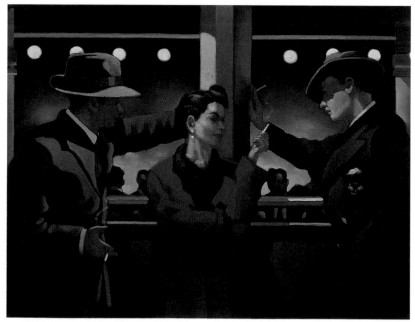

QUEEN OF THE FAN-DAN (ABOVE) CLEO AND THE BOYS (BELOW)

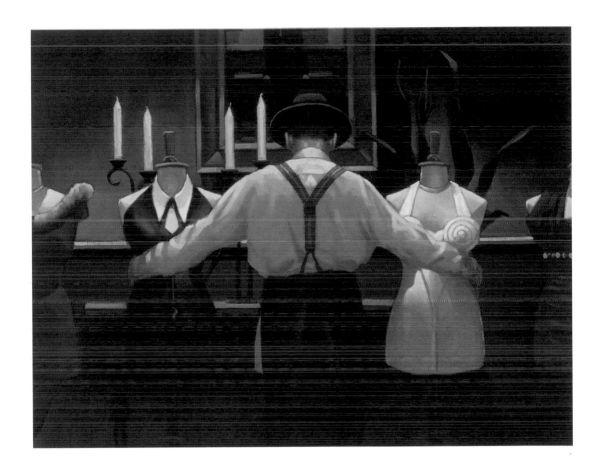

A KIND OF LOVING

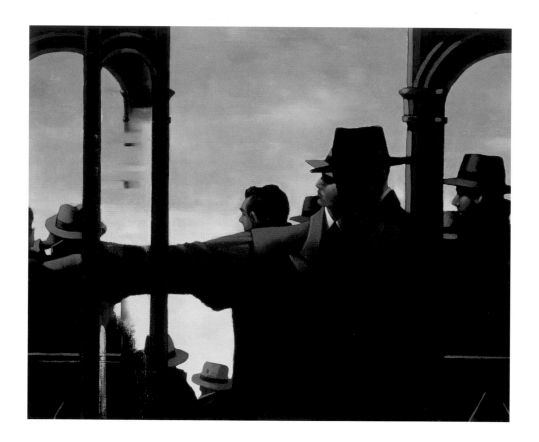

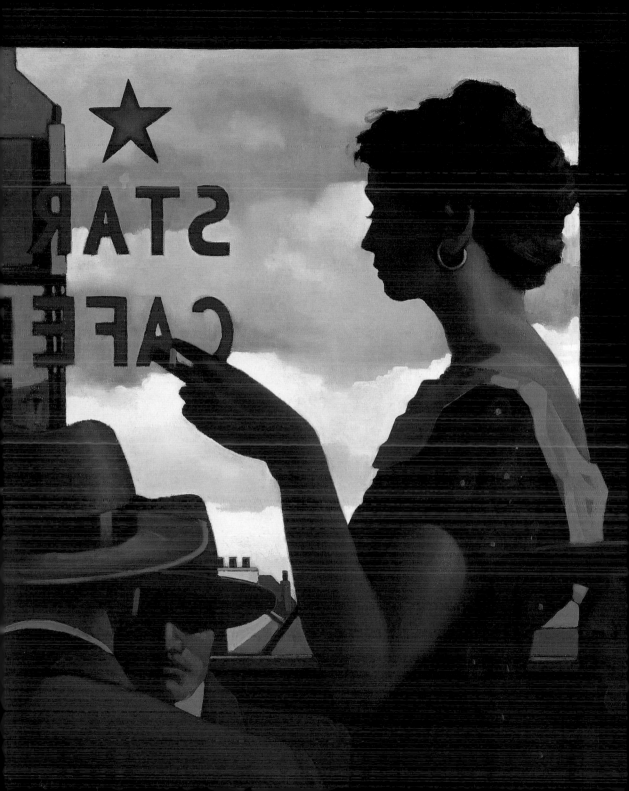

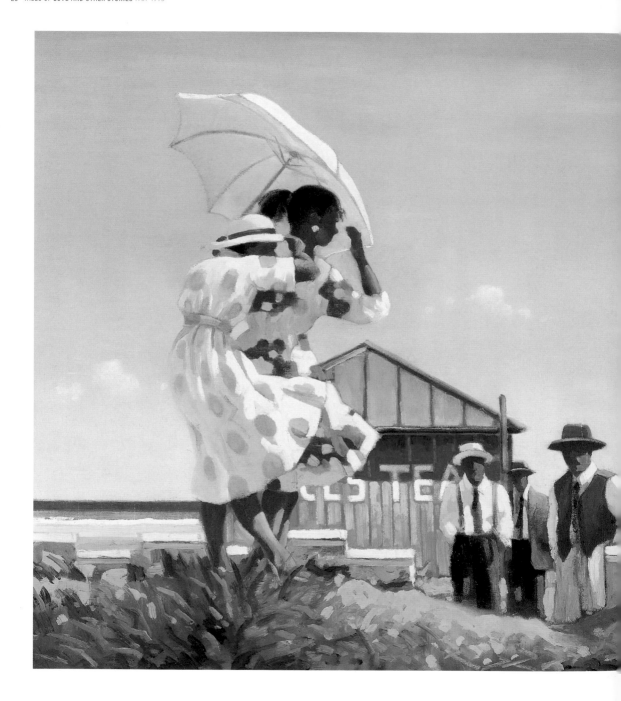

A VERY DANGEROUS BEACH

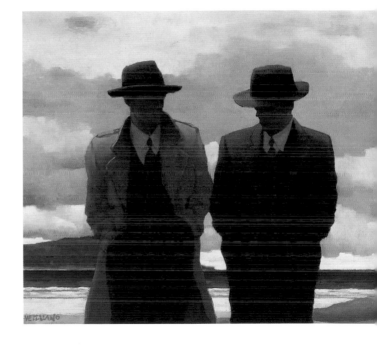

AMATEUR PHILOSOPHERS

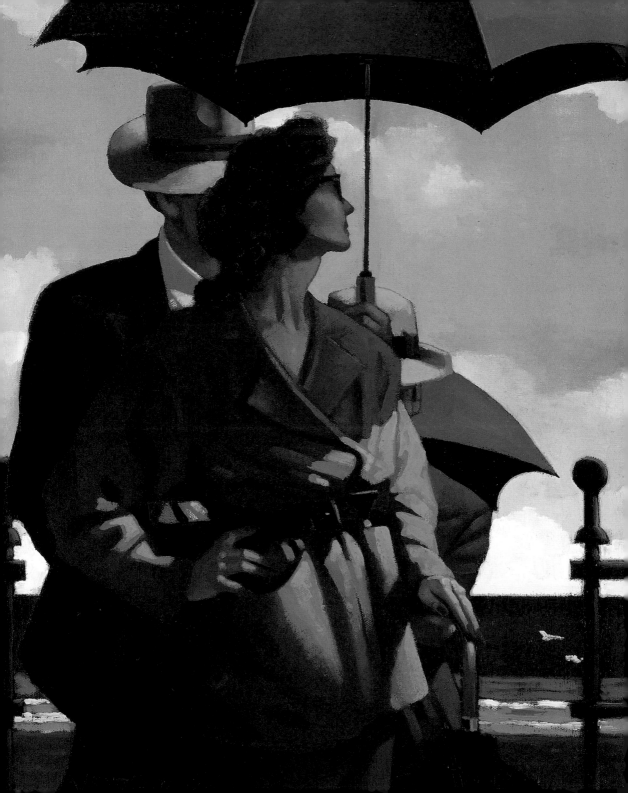

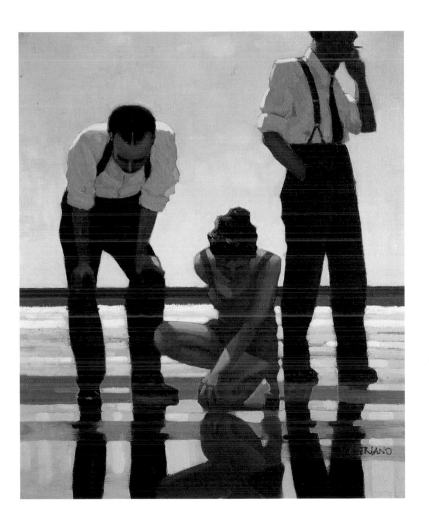

RIGHT TIME, RIGHT PLACE NARCISSISTIC BATHERS

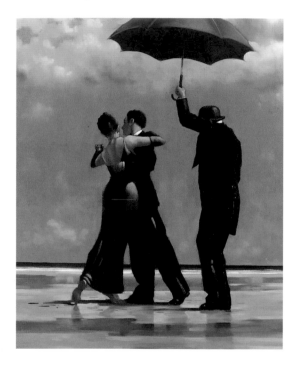

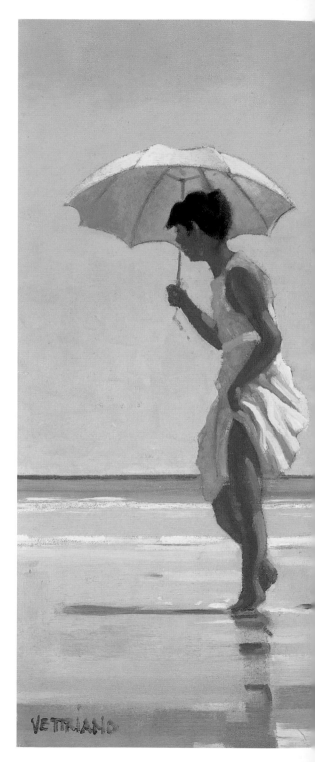

THE SINGING BUTLER II MAD DOGS

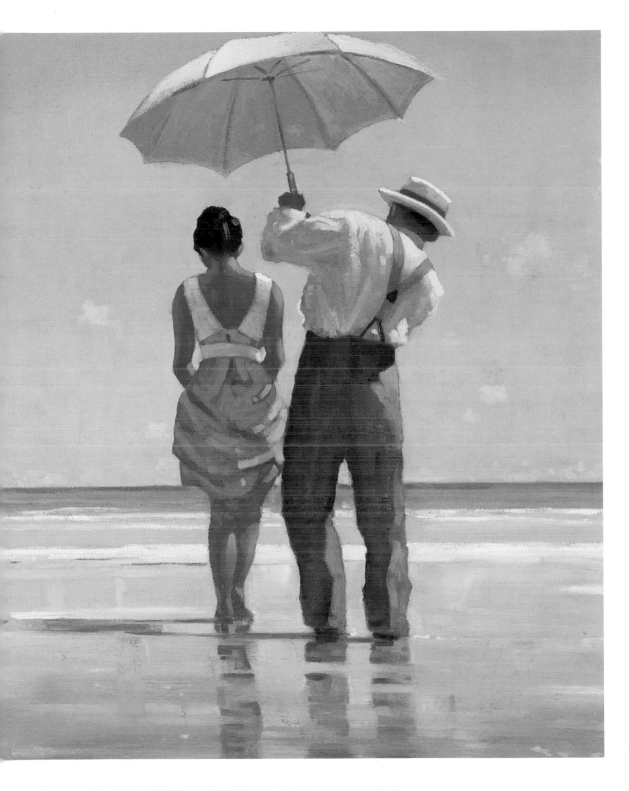

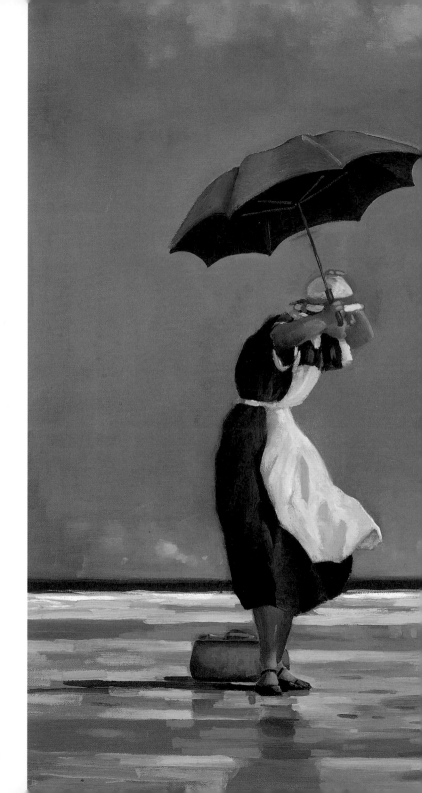

Vettriano's is "a cool, sharp world of edgy romance and sexual tension. He has the ability to make you feel nostalgic for things you never actually experienced in the first place."

SIR TIM RICE

THE SINGING BUTLER

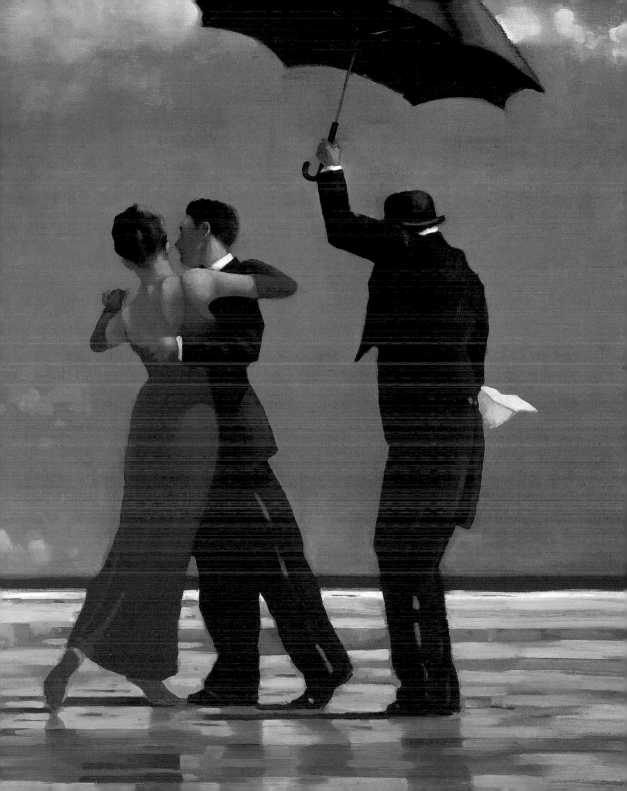

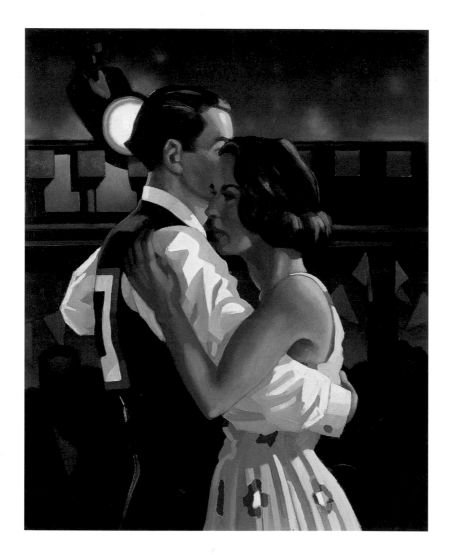

COMPETITION DANCERS

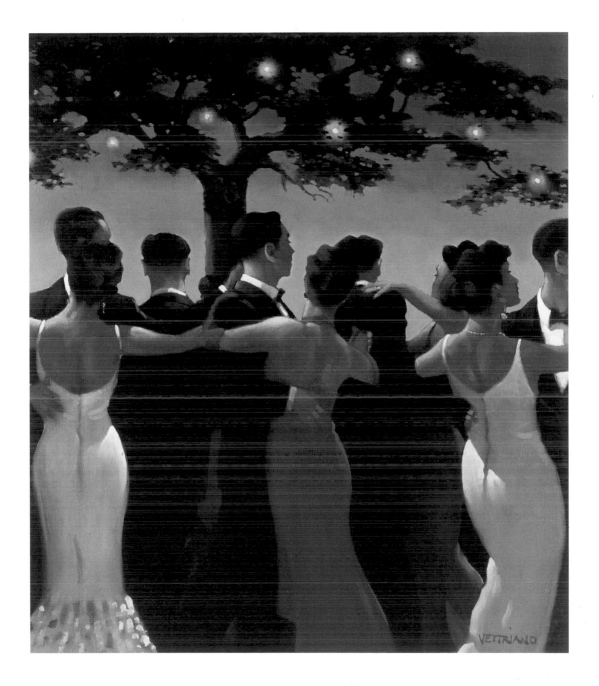

WALTZERS

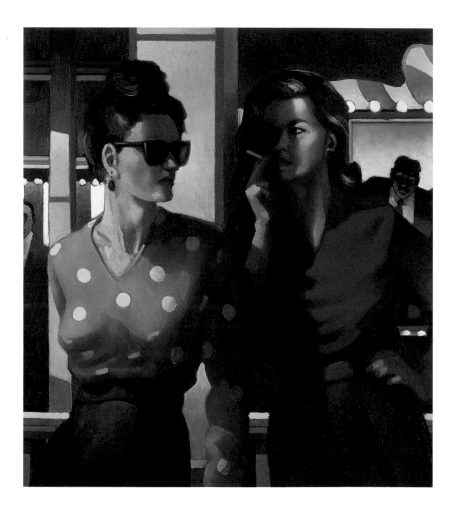

GOOD TIME GIRLS

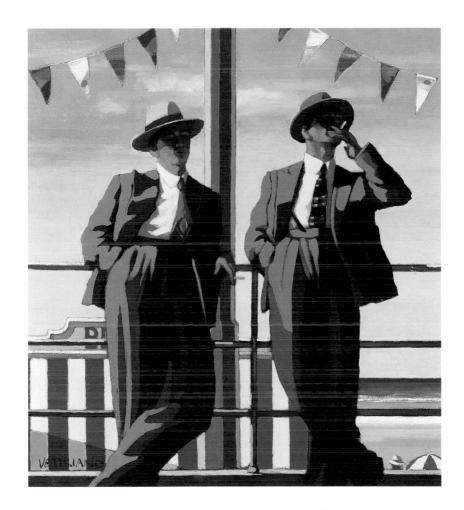

SEASIDE SHARKS

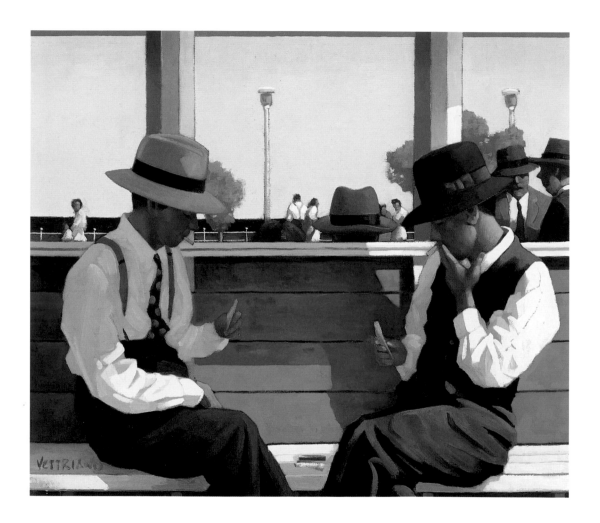

THE DUELLISTS

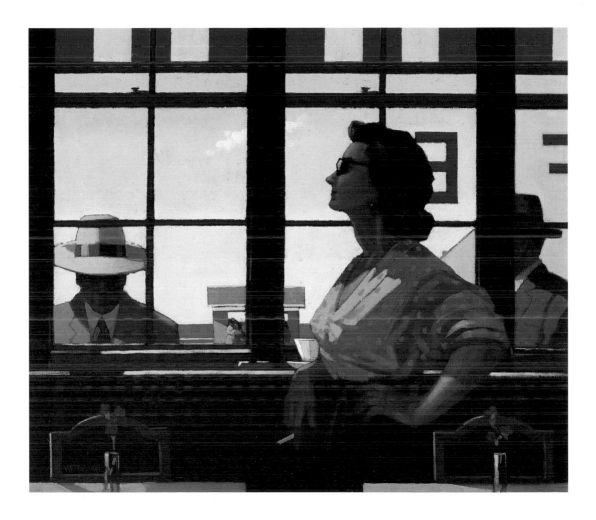

A DATE WITH FATE

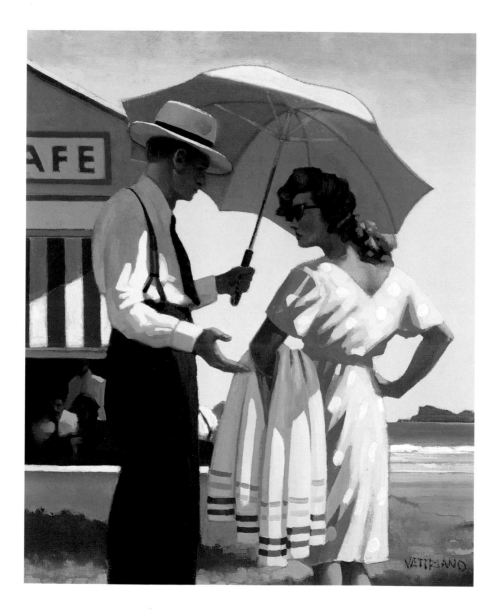

THE DIRECT APPROACH

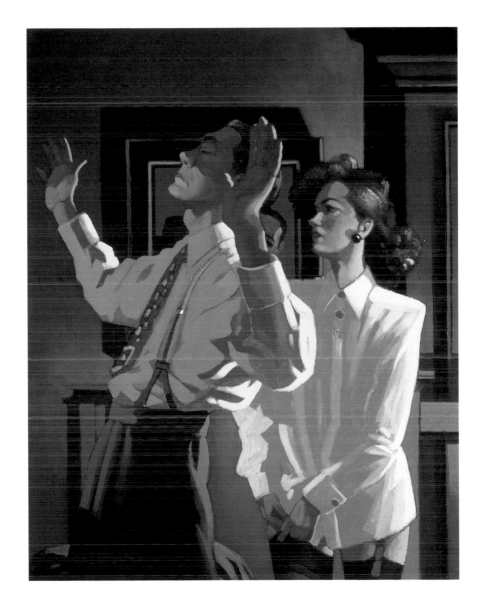

THE STRANGE CASE OF MR MOONLIGHT

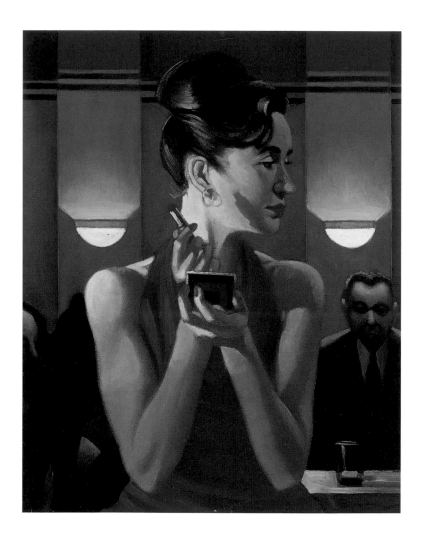

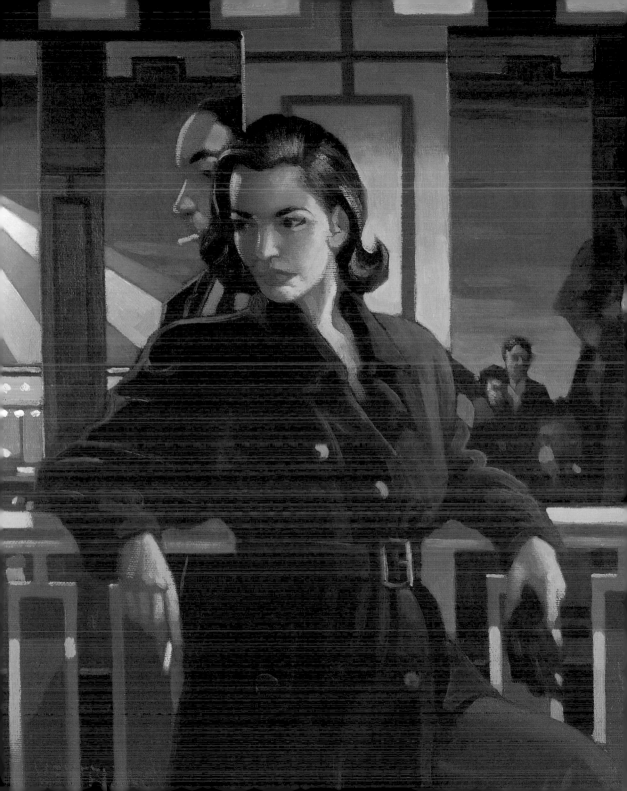

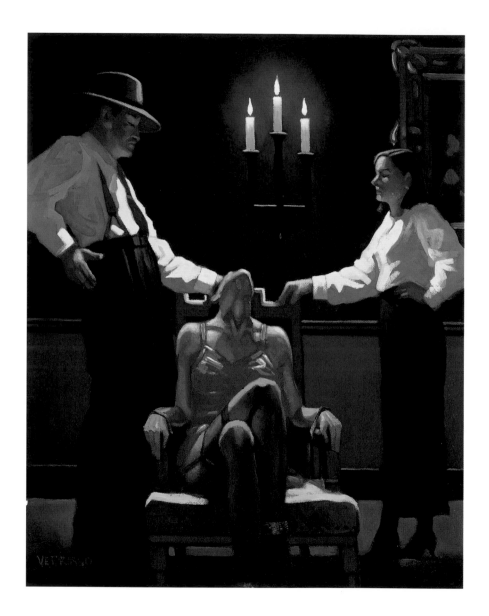

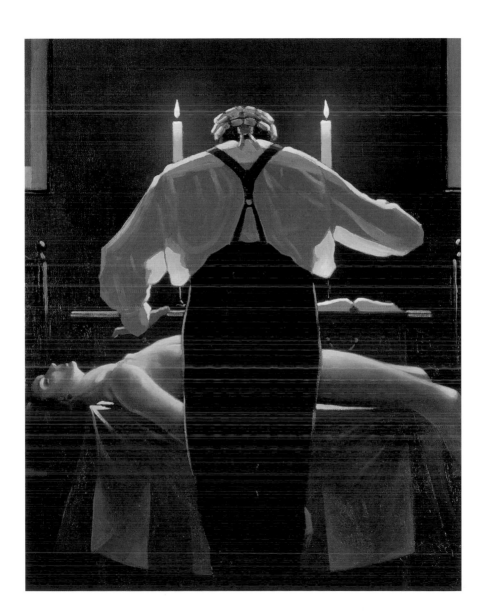

THE ADMINISTRATION OF JUSTICE

THE PASSION AND THE PAIN
1994 – 1996

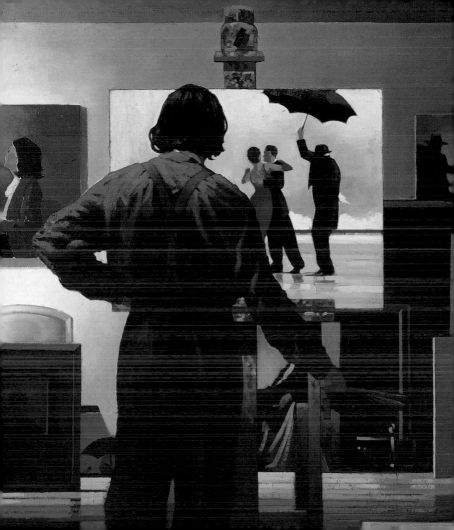

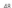

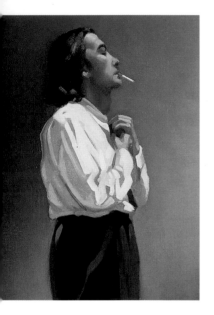

In early 1993 a friend had advised Tom Hewlett of the Portland Gallery that he might take a look at a certain Scottish painter, name of Jack Vettriano, whose work was currently flying off the walls in Edinburgh and Newcastle. Hewlett travelled to Edinburgh to meet Vettriano at his studio in Castle Terrace. Hanging on one wall was a large, recently completed painting. Vettriano asked Hewlett what price he might get for it. "I told him a figure", says Hewlett, "and he said, 'Well, if you can get that for it, then do'. So I did, and that was the start of it." They agreed terms, and a partnership was up and running. They celebrated with dinner at Raymond Blanc's Manoir aux Quat' Saisons. Blanc was so impressed with the painter that he hung a whole suite at the Manoir with Vettriano originals and named it after him.

Vettriano's first Portland Gallery show, a collection of forty-eight paintings under the title *Chimes at Midnight*, opened on 12 October 1994. It sold out. At the same time, alert to the ground swell of public interest, Pavilion Books in London had commissioned Gordon Smith to compile an anthology, *Fallen Angels*, in which over forty Vettriano images were accompanied by a selection of Scottish writing. Poets, playwrights, novelists and actors were asked for a personal response to an individual painting or poem – by Burns or Robert Louis Stevenson – was selected to complement a particular image. Smith himself provided an excerpt from his play about van Gogh to accompany *A Test of True Love*, in which a man makes a profession of love to a woman in a restaurant by coolly placing his hand over the flame of a candle.

Film, and *film noir* especially, has played a significant part in shaping Vettriano's imagery. *The Billy Boys*, for example, is a quotation from the poster of Quentin Tarantino's debut *Reservoir Dogs*, in which masculinity and menace are combined in the image of men strolling confidently abreast. But it's not a straightforward homage. The men's attire in the painting owes more to the retro look of *The Godfather*, while the title of the painting derives from a song Vettriano's father used to sing about "the Leven Billy Boys". "I think it's a

reference to King Billy, even though the Protestant-Catholic thing doesn't really touch the east coast of Scotland. Basically, these guys are walking from one town to another, and they're going to rough up another crowd." In truth, these men look more likely to break hearts than break heads – and why risk those fine clothes in a scrap? They mean business, for sure, but the mixture of influences feeding the painter's memory leaves the precise nature of the business uncertain. Tarantino figures again in *The Parlour of Temptation*, where the woman's provocative pose, heels kicked up behind her, mimics that of Uma Thurman on the poster for *Pulp Fiction*.

It was during this time that Vettriano moved to Lynedoch Place, an elegant Georgian terrace in the west end of Edinburgh. It would become not just his home but the stage set for his paintings. The walls were painted a theatrical shade of burgundy. A cupola at the top of the stairwell offered abundant natural light for his preparatory photographs. An original Georgian handrail furnished a focus not only for interior paintings, but for beach scenes which he could simulate conveniently indoors. Paintings such as *The Purple Cat* were conceived around the hallway, where he hung drapes in the manner of tableaux from Peter Greenaway's *The Cook, The Thief, His Wife and Her Lover*.

Even his garden was put to use as a backdrop for his latest work, a series of paintings commissioned by Terence Conran, a longtime fan, for his Bluebird restaurant on the King's Road. "All he said to me when we discussed the brief was, 'Try to make the cars look sexy'." It proved more difficult than he imagined. "It's hard enough to please the client who walks in off the street, but trying to please one of the best-known designers in the world, that was tough." His efforts were not in vain. The sheen of reflections on the wet sand in *Pendine Beach*, which he spent hours trying to perfect, is quite beautiful, and *Bluebird at Bonneville*, with its shimmering palette of blues and whites, catches wonderfully the parched noontime air. "It drove me bonkers", he recalls. But Conran was delighted.

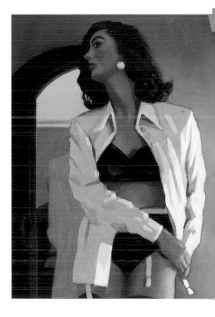

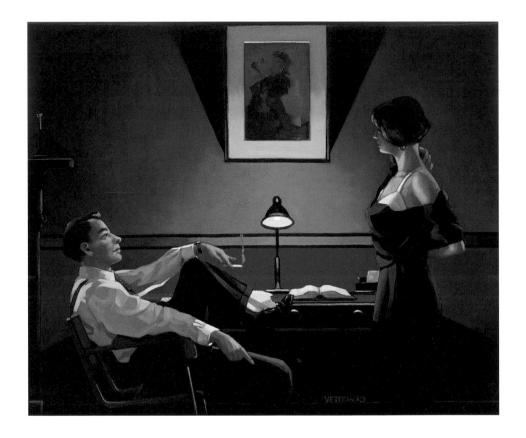

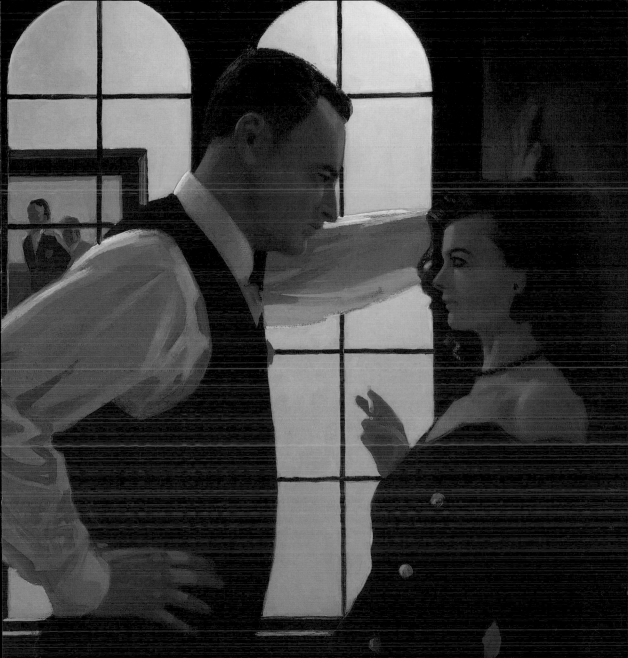

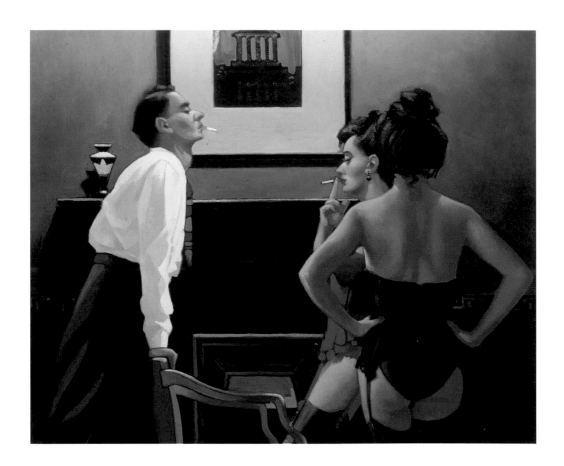

THE MASTER OF CEREMONIES

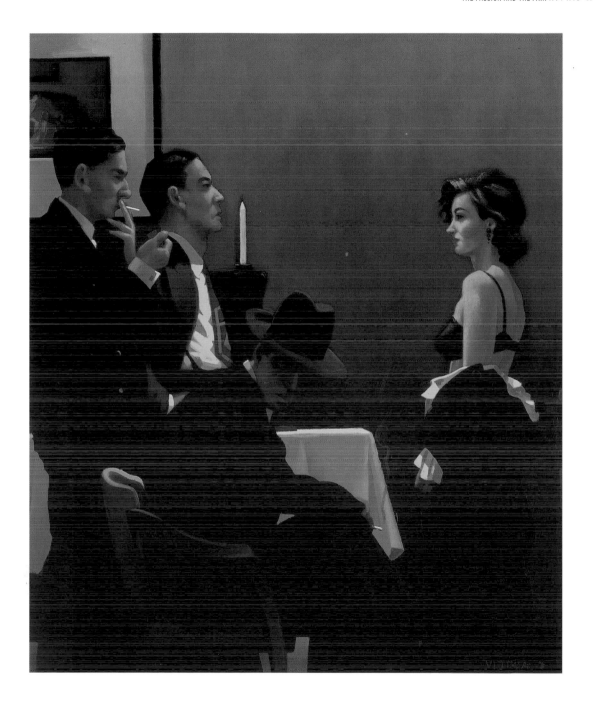

WE CAN'T TELL RIGHT FROM WRONG

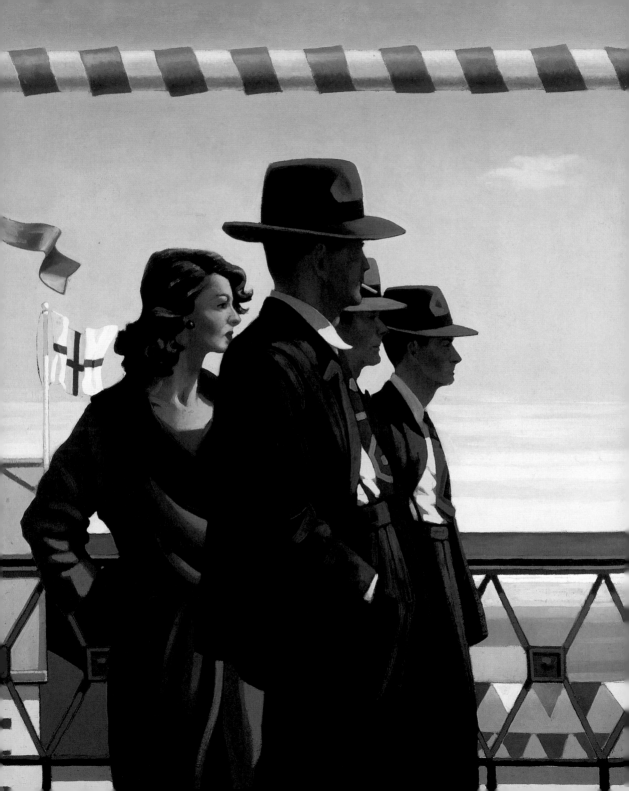

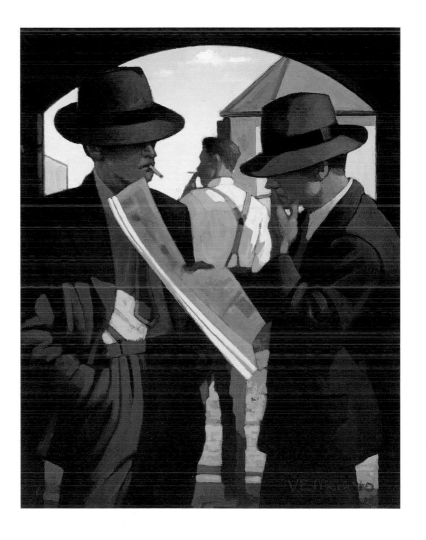

THE DEFENDERS OF VIRTUE BAD, BAD BOYS

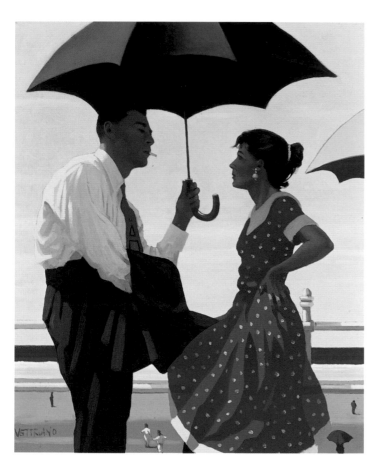

"I have this nostalgic feel about the past. I seem
to have spent my life wistfully looking back. I live
more for yesterday than I do for tomorrow."

JACK VETTRIANO

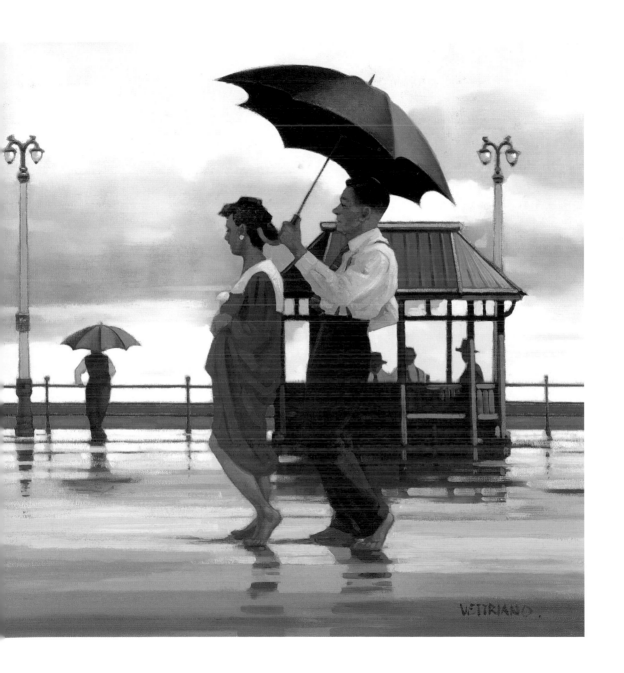

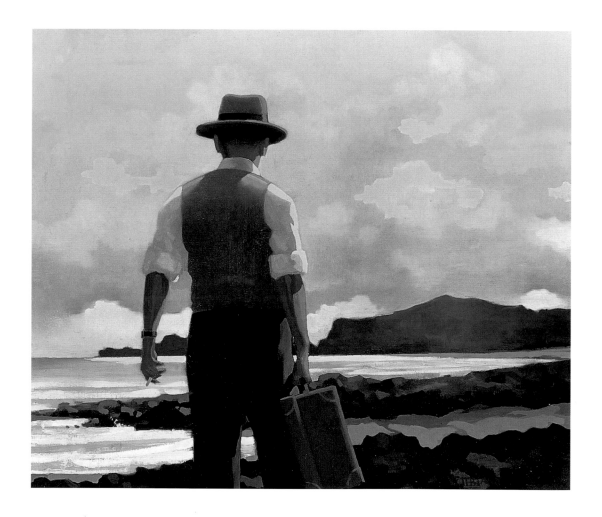

THE DRIFTER

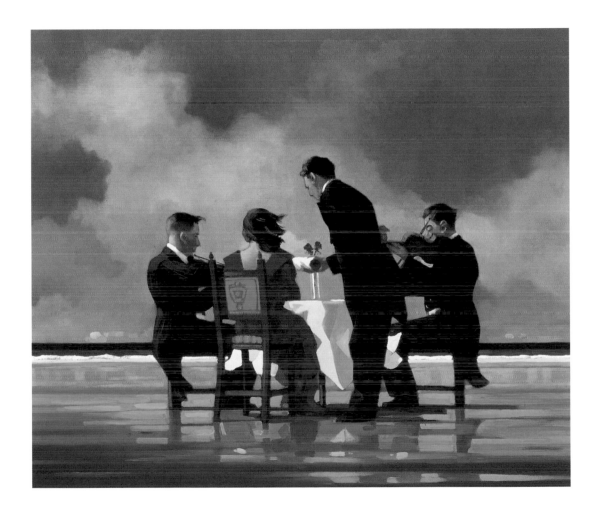

ELEGY FOR THE DEAD ADMIRAL

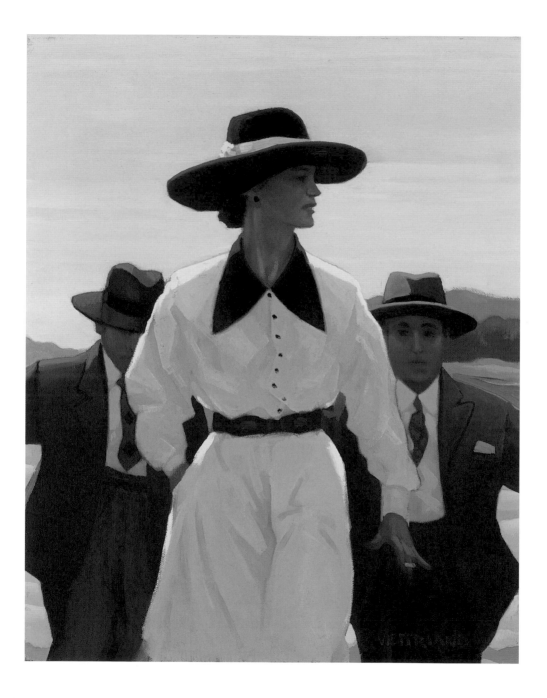

WOMAN PURSUED

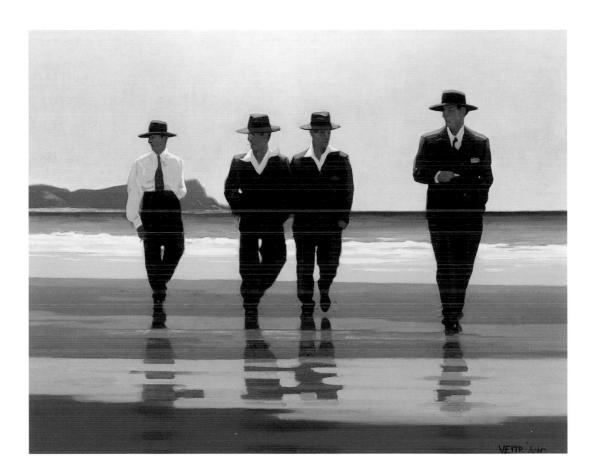

THE BILLY BOYS

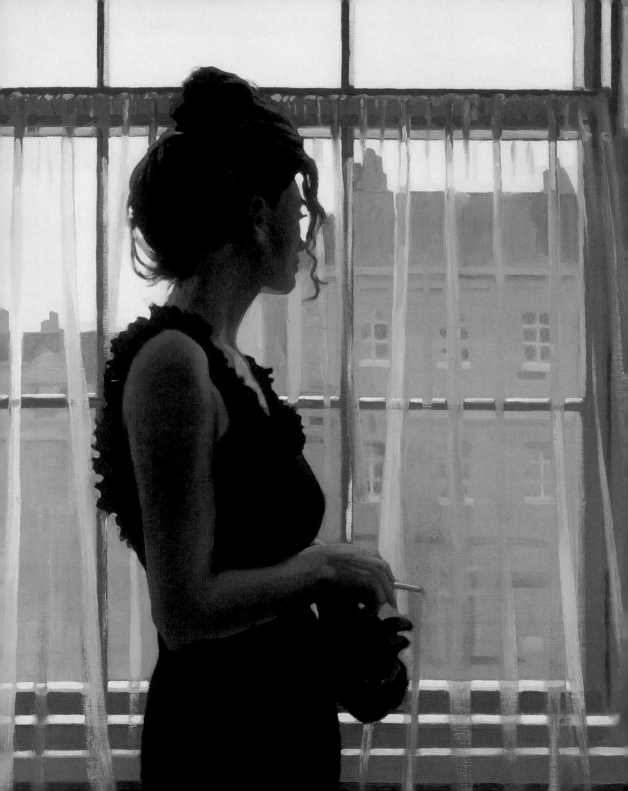

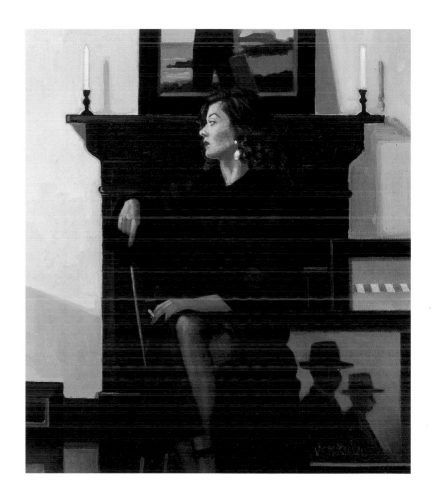

YESTERDAY'S DREAMS MODEL IN BLACK

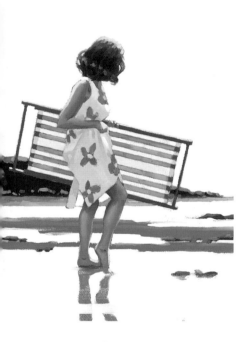

SWEET BIRD OF YOUTH (STUDY)

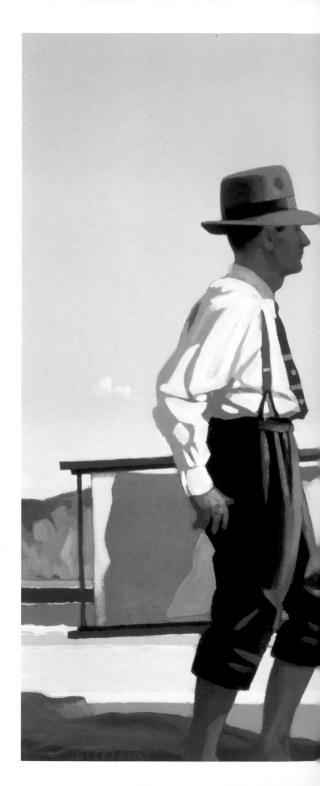

SWEET BIRD OF YOUTH

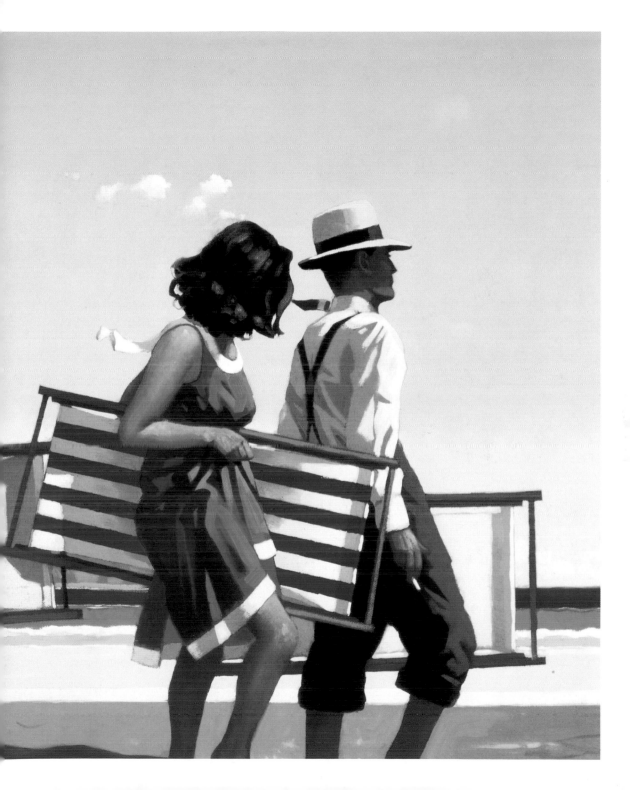

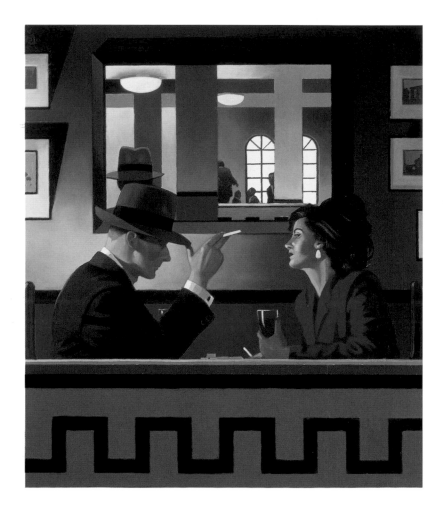

THE MAN IN THE MIRROR

THE TWILIGHT ZONE

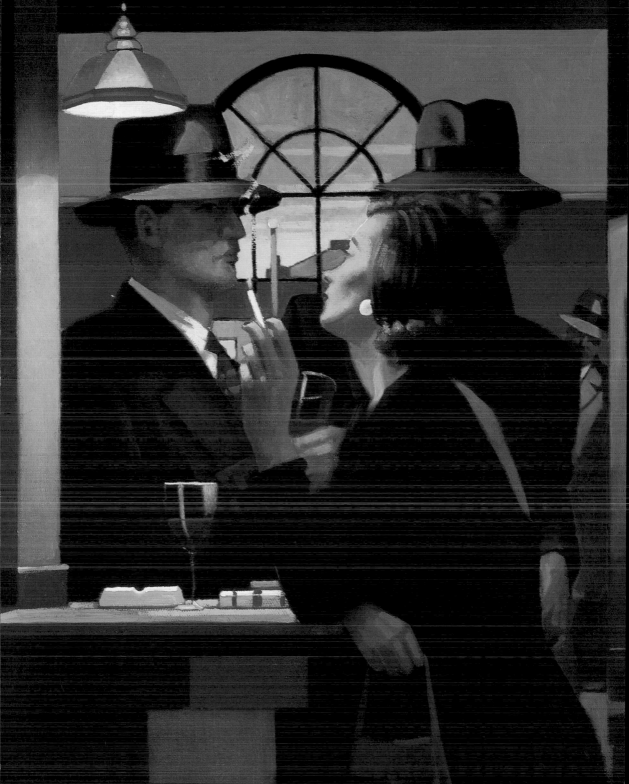

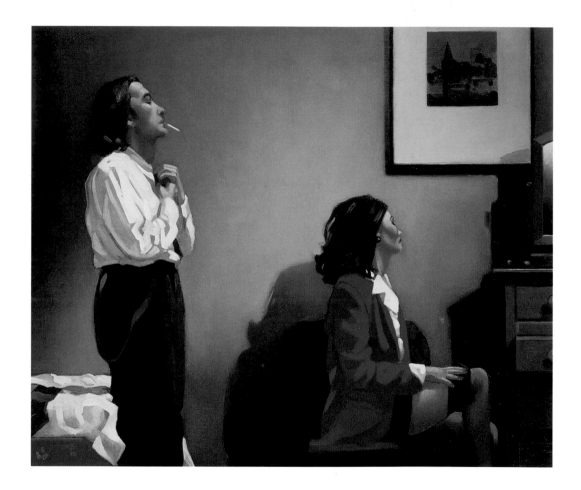

COLD COLD HEARTS

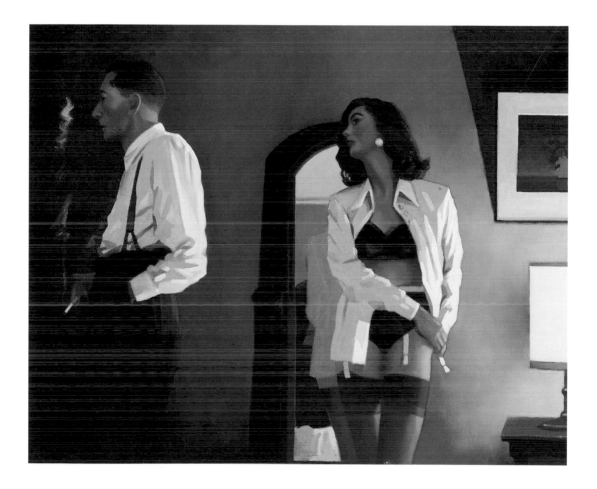

HOW DO YOU STOP?

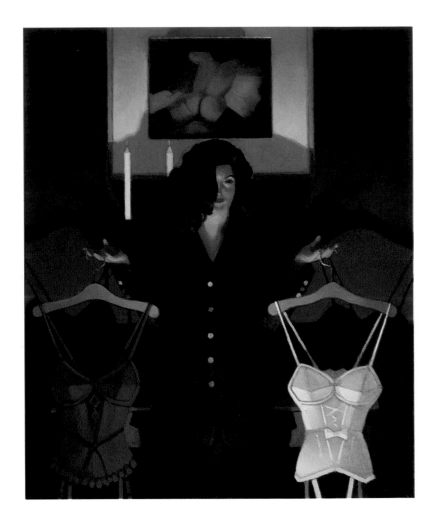

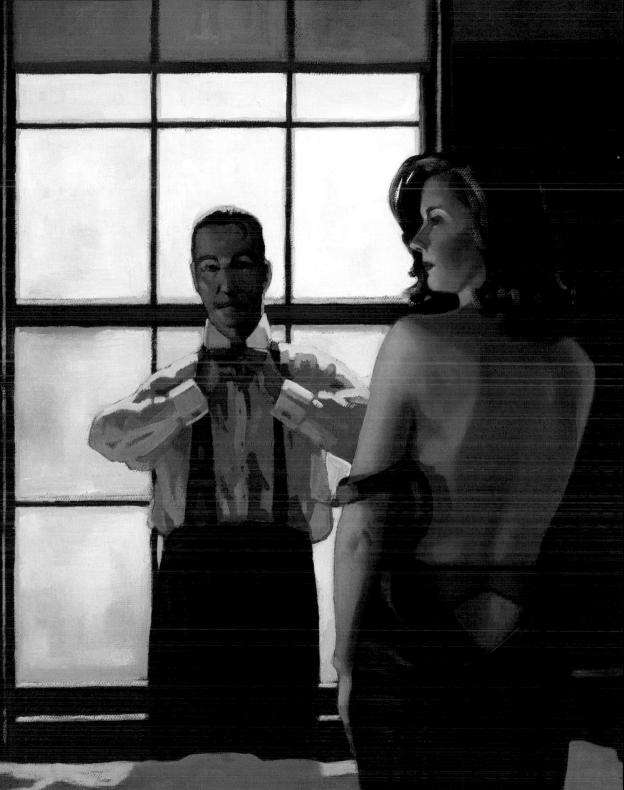

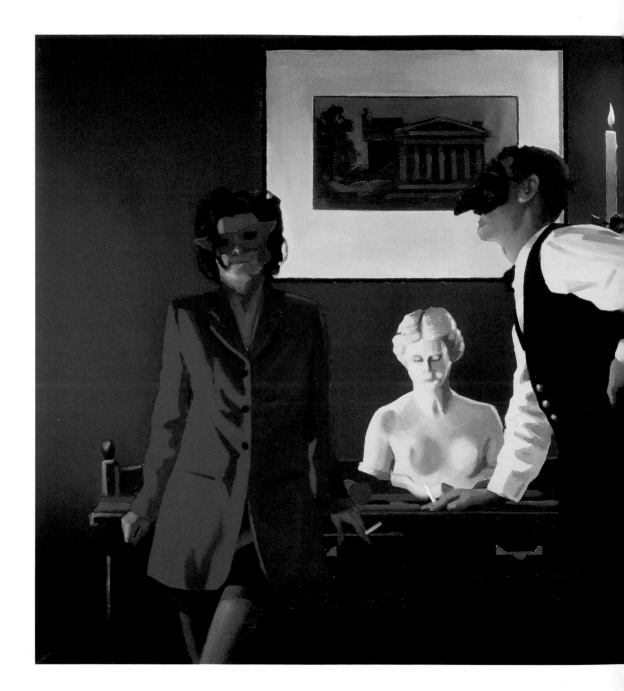

THE SPARROW AND THE HAWK

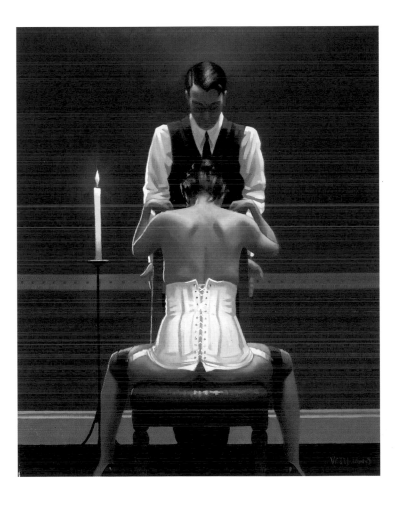

THE PERFECTIONIST

"I just happen to think it's pretty
fundamental, everybody everywhere is
driven by the urge to do it. It is a
powerful force and only the strong and
happy are able to resist it."

VETTRIANO, TALKING ABOUT SEX

THE PARTY'S OVER

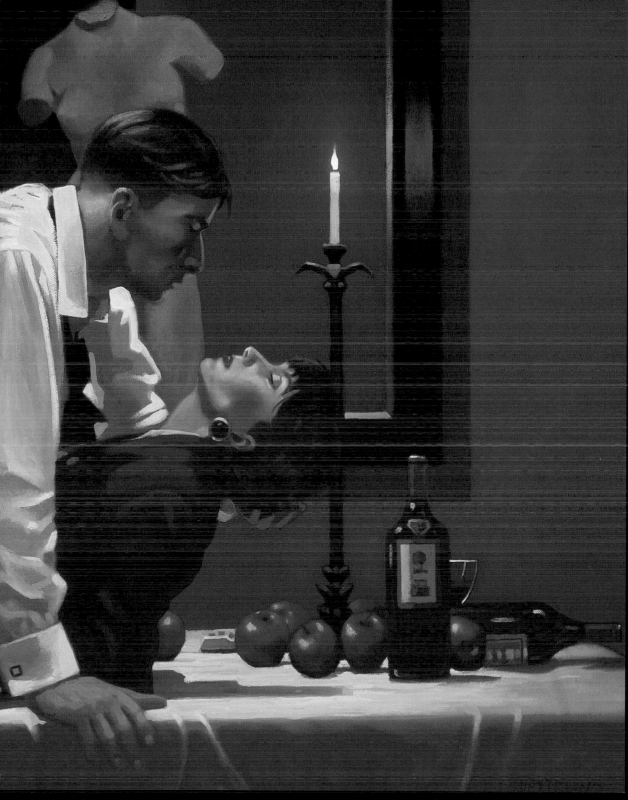

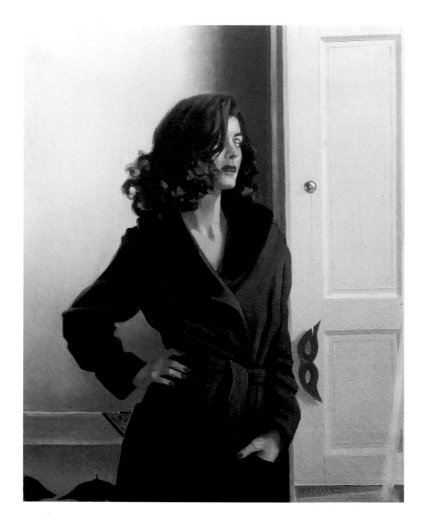

DRESSING TO KILL

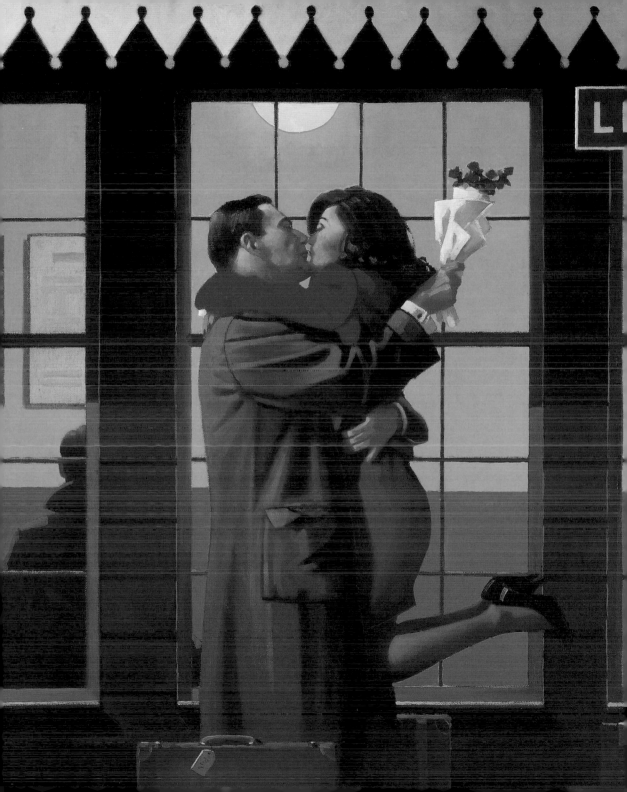

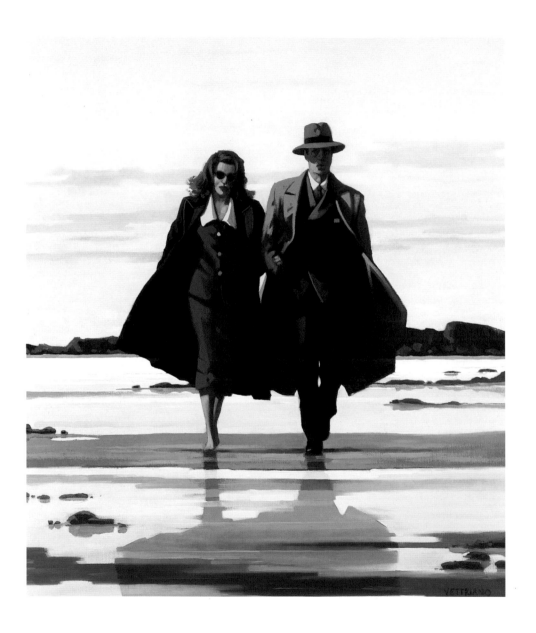

THE ROAD TO NOWHERE

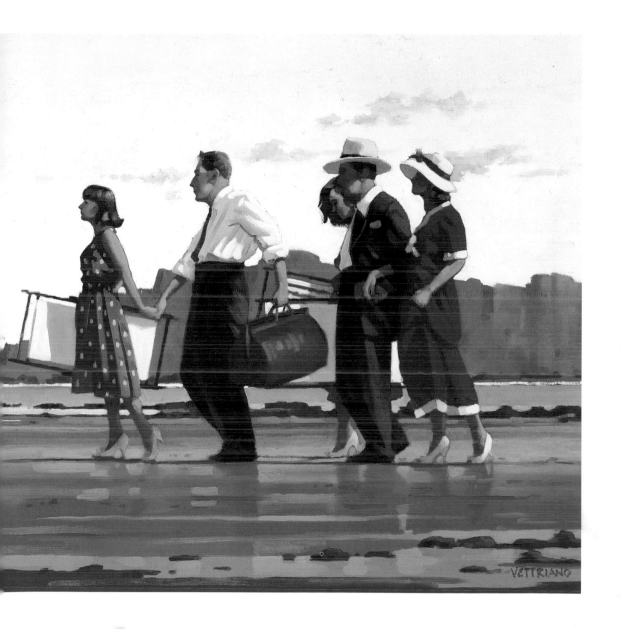

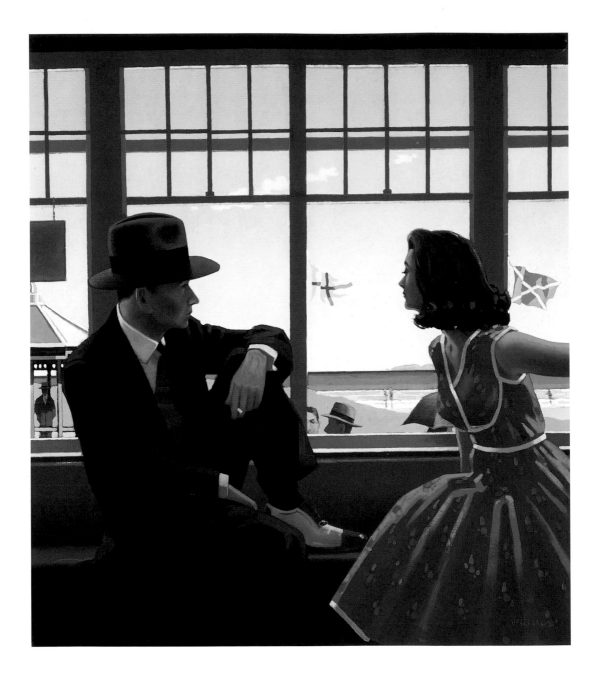

EDITH AND THE KINGPIN

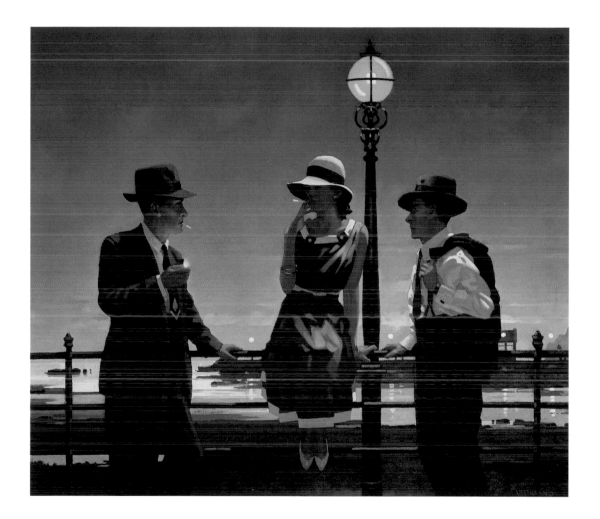

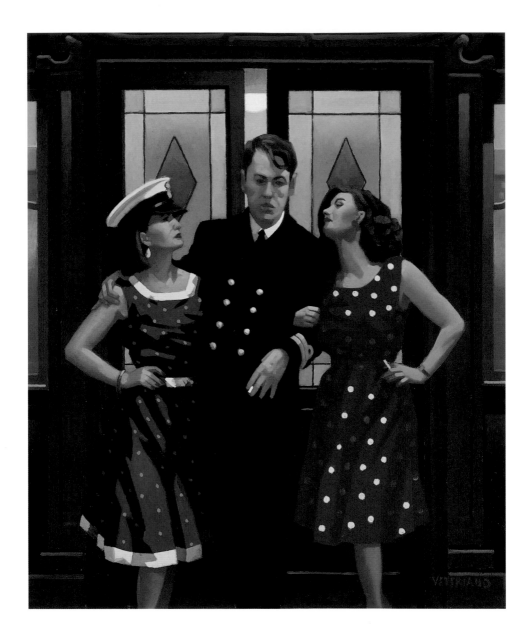

AND SO TO BED

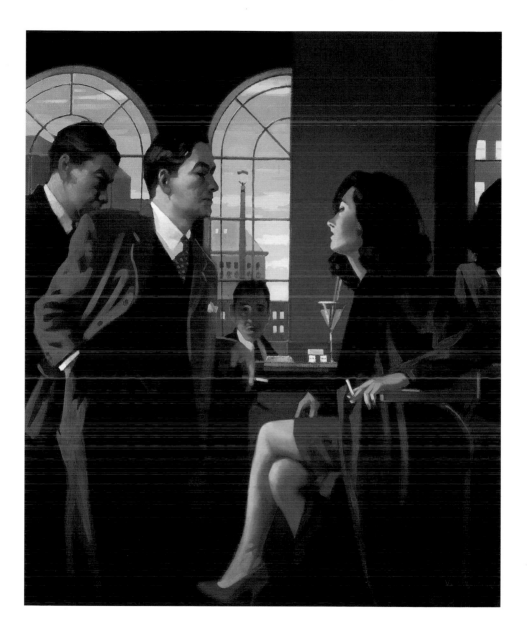

THE RED ROOM

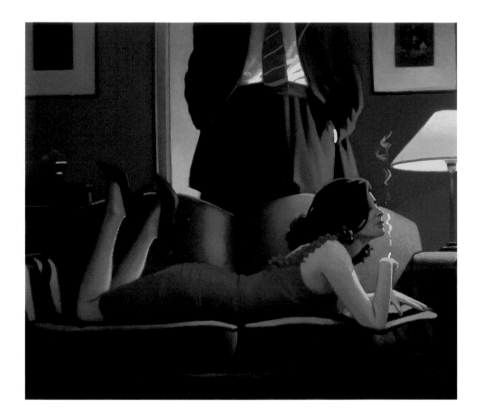

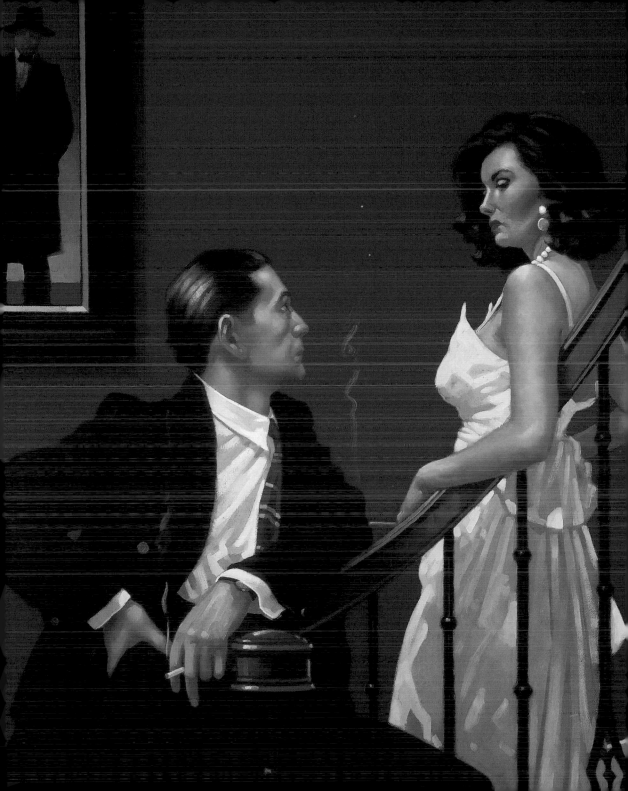

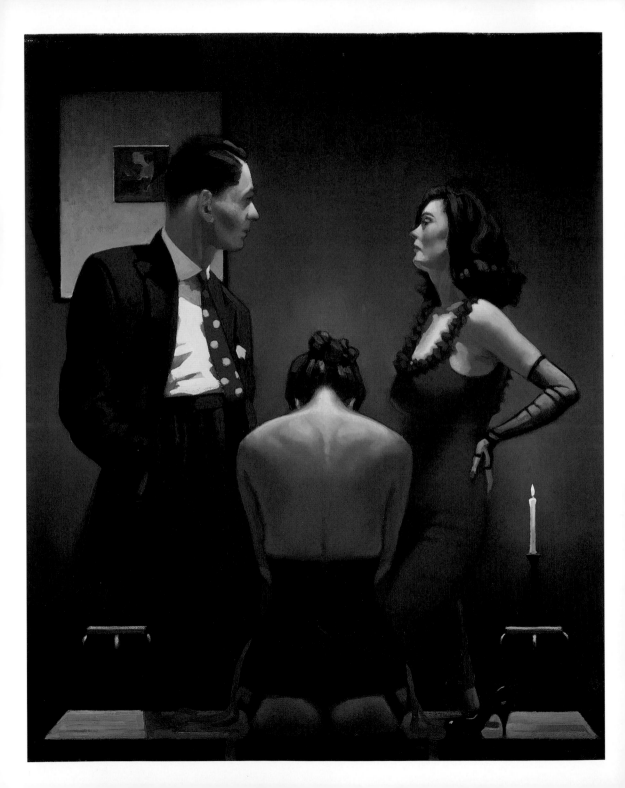

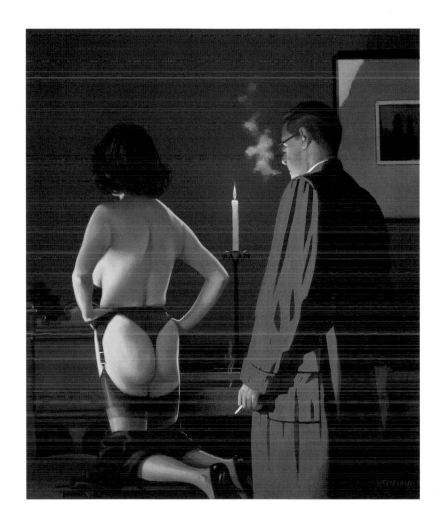

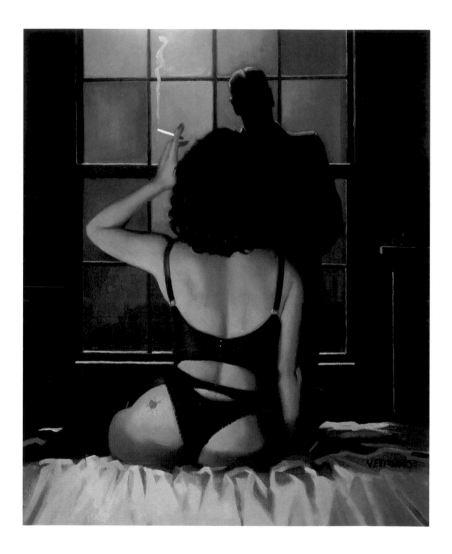

ROUND MIDNIGHT

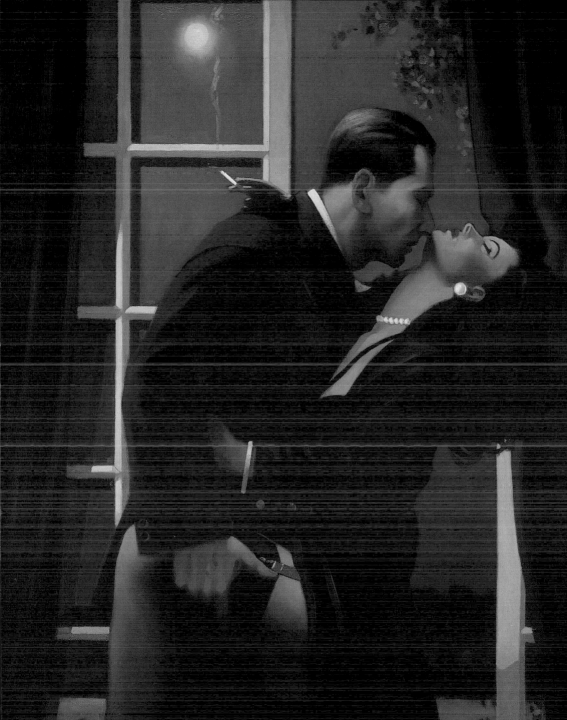

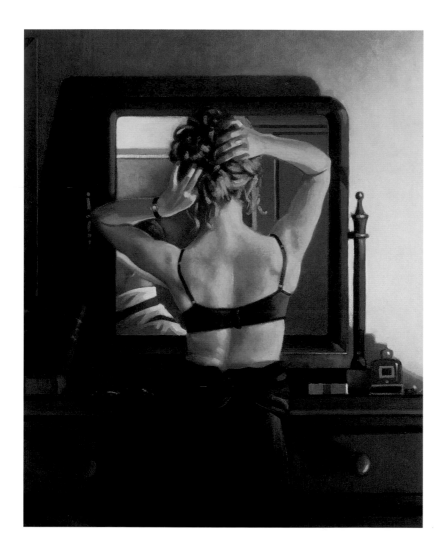

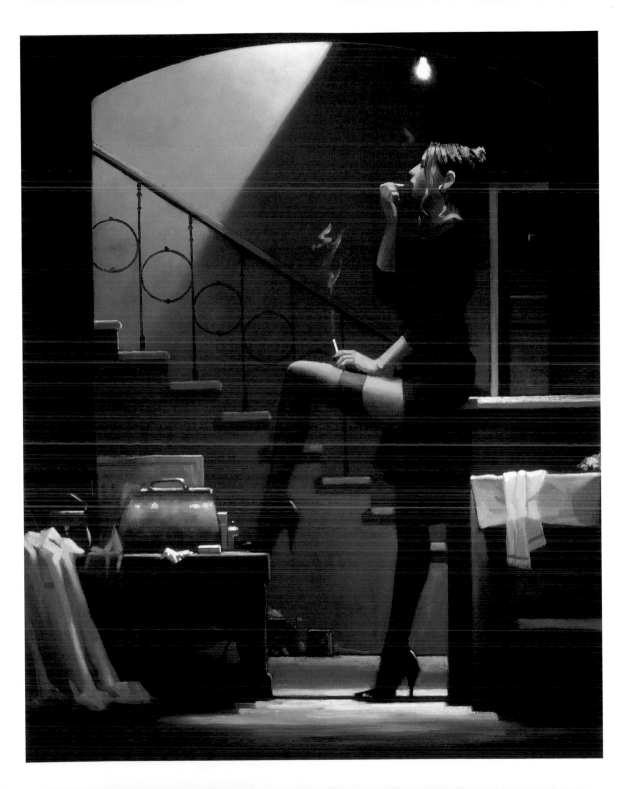

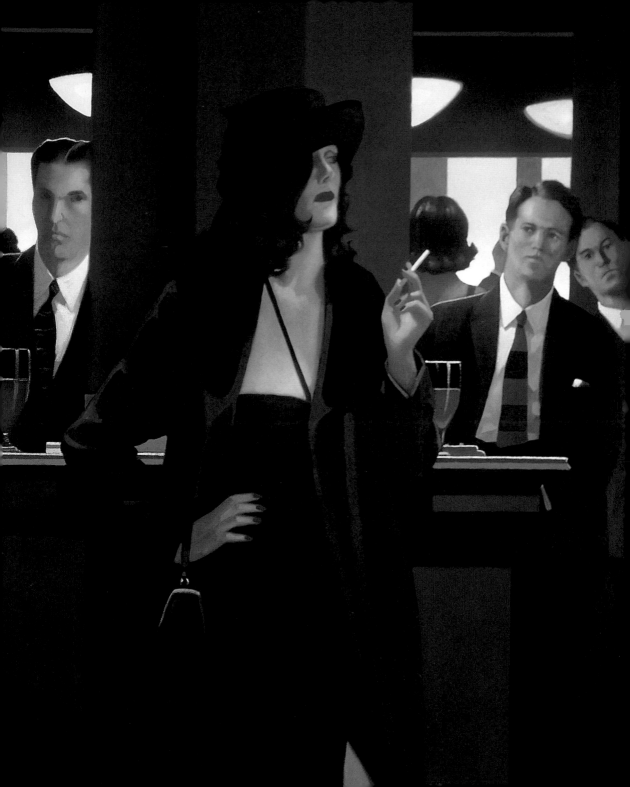

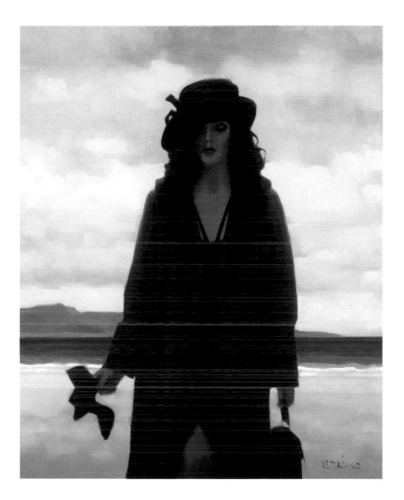

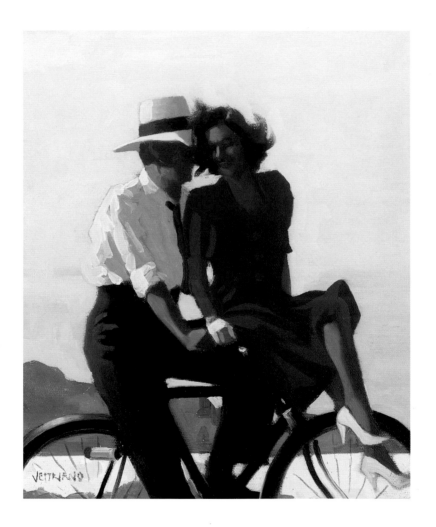

LAZY HAZY DAYS

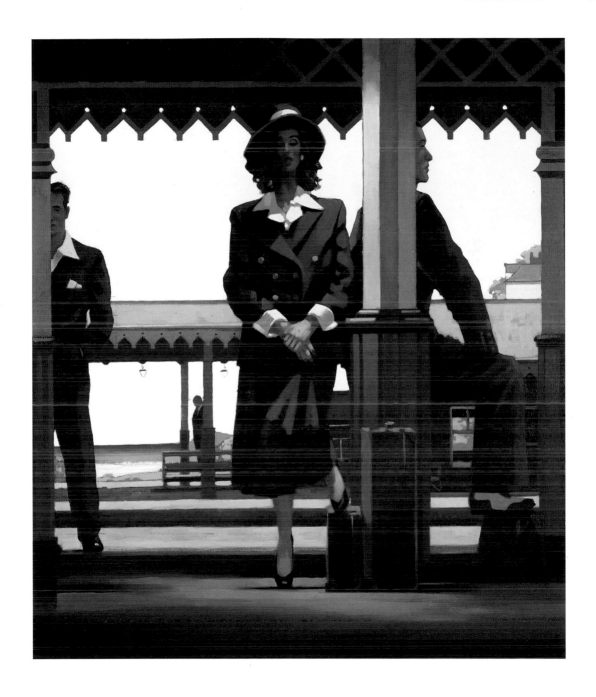

THE RAILWAY STATION

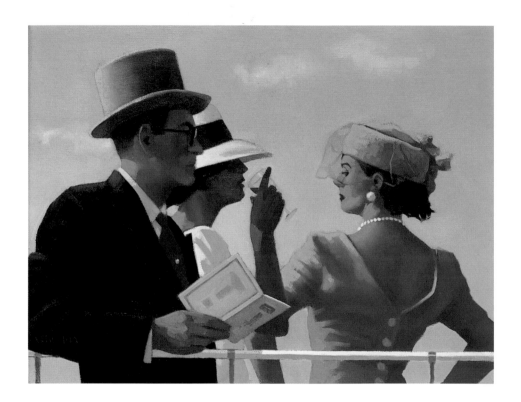

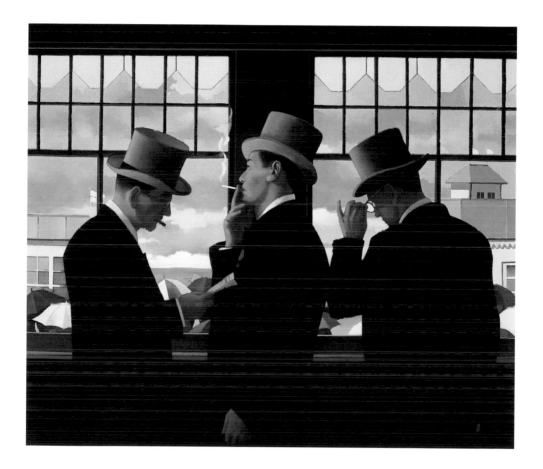

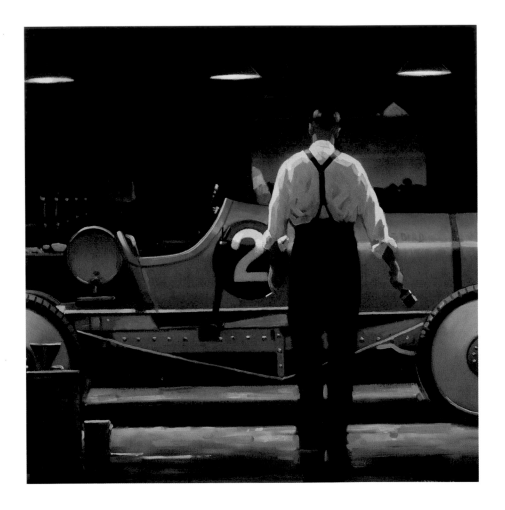

BIRTH OF A DREAM

PENDINE BEACH

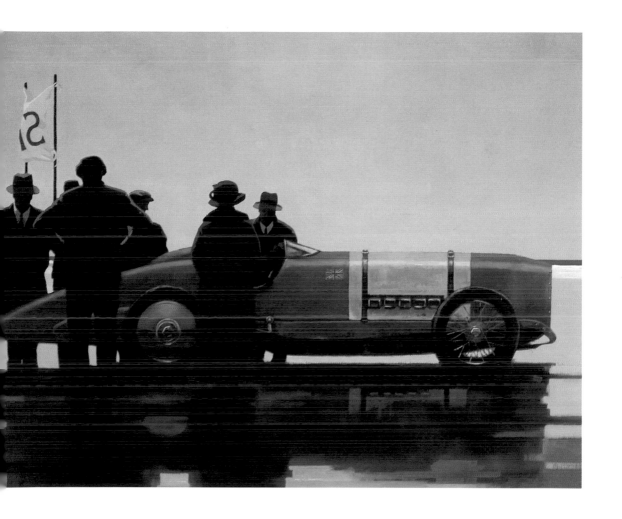

OVERLEAF: BLUEBIRD AT BONNEVILLE

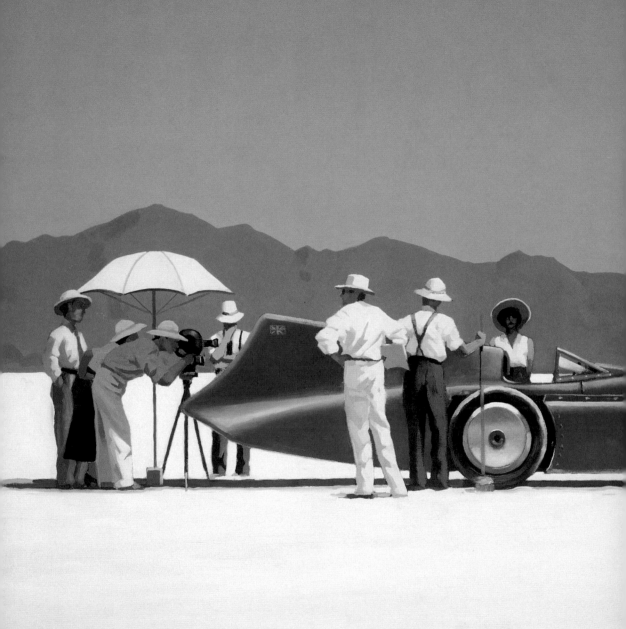

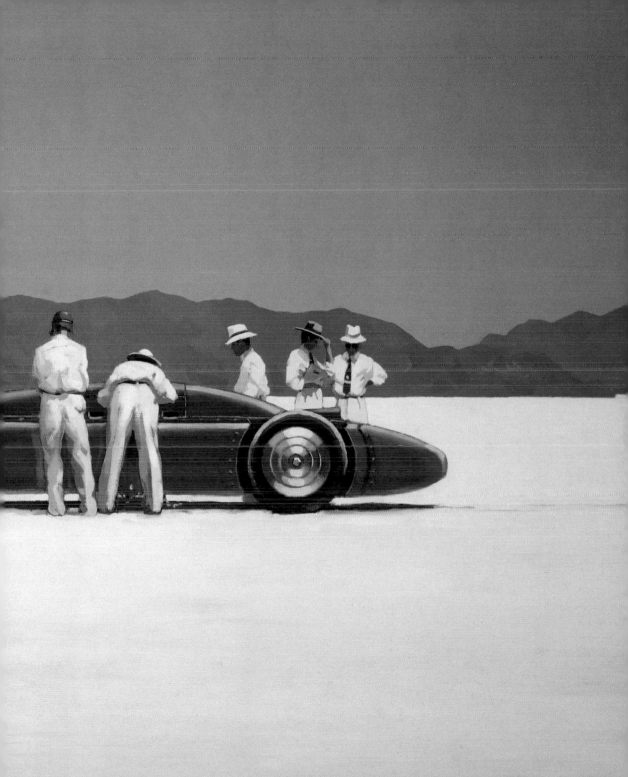

LOVERS AND OTHER STRANGERS
1997 – 2000

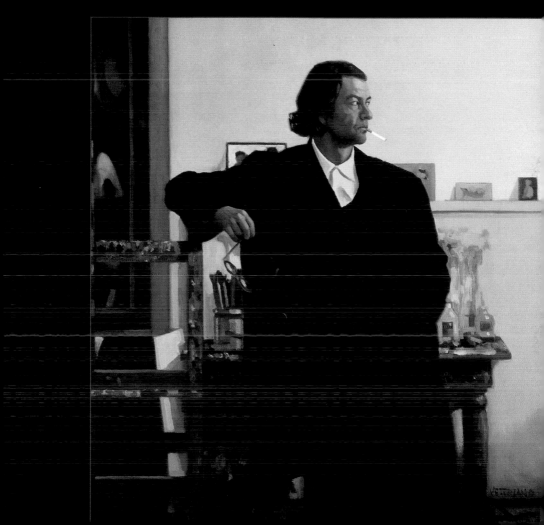

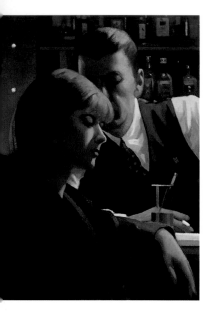

In 1998 Vettriano moved to London, feeling that he had become too visible in Edinburgh. He was also increasingly paranoid about the attentions of the tabloid press, whose prying culminated in 1999 with a story about his alleged stalking of a woman some eight years previously. The police had investigated and brought no charges, but the story was now on the record and it cast a deep pall of depression over Vettriano and his family. In an *Observer* profile in June 2004, Lynn Barber suggested to him that "a bit of louche behaviour" wouldn't necessarily compromise his image, to which he replied, "Louche behaviour might be me being photographed going into a hotel room with a couple of girls – that's fine. But stalking is not. Stalking is a crime, and there's a big difference between that and having a wee bit of sex fun."

Sex and fun, in truth, are seldom bedfellows in Vettriano's work. Erotic encounters are loaded with associations of danger, furtiveness, even guilt, and mostly happen in a world of shadows. One needs only glance at certain paintings of this period – *Cocktails and Broken Hearts*, *Private Dancer*, *Under Cover of Night* – to grasp these implications. "That world has always had a strong attraction for me", he says, "the kind of world where you leave no traces. The next morning it's as though it's never happened, and OK, you might get a bit depressed about it but you only feel like that till 6 o'clock when you start getting ready to go out and do it again." He knows too well his own susceptibility to temptation. When he was looking for a suitable part of London to settle in, his natural proclivities drew him, moth-like, to the neon allure of Soho, but good sense soon prevailed. "I knew more or less instantly that it would be a bad move. I've seen how that world operates, I already knew how fascinating and sordid it can be. It's not a recipe for happiness."

Yet if he is alert to the dangers of casual sex, he also dreads the warm embrace of domesticity. Like many a true romantic, he is most himself when alone. "I don't know whether I hide behind that or not. I suspect I do, but there is a genuine fear that if you're not 'out there' then your creativity will be

affected. I can understand how a woman listening to that would say, 'You're
a ---- and I don't want anything to do with you.' But I think anyone who
values their creativity would be careful about the way love affected them, and
given the work I do I've got all the more reason to be scared." The ravenous
sexual charge of paintings such as *Scarlet Ribbons* and *The Assessors* gives fair
warning that Vettriano would not easily succumb to the pipe and slippers.

In June 1998 his new show, *Between Darkness and Dawn*, opened at the
Portland Gallery, and featured some of his most assured and dexterous work
yet. The early morning light and melancholy quietude of *Portrait in Silver and
Black* are amongst his most beautiful effects. *Dance Me to the End of Love*
became one of his most widely reproduced images, and marked a temporary
cessation of beach scenes in his work. His attitude towards such overtly
"romantic" paintings is ambivalent. "I feel that more beach paintings would
give critics ammunition, so I've forced myself to steer clear of them. On a
good day I'm fairly proud of them, but it's a double-edged sword because
they're also responsible for some of the flak I've received."

Lynn Barber decided that there were two Vettrianos, "nice JV who goes in
for butlers and ballgowns and nasty JV who goes in for sex games." He rejects
this as simplistic. He painted the beach scenes "not because I was feeling
'nice' but because I wanted to get a particular effect with reflections. Gordon
Smith once said something similar, that a small part of my personality was
very hopeful and romantic but the greater part is very cynical and bleak."

What's misconceived in this binary view of his character is the assumption
that his "nice" and "nasty" sides are perfectly separable, whereas they are in
fact closely interrelated with each other. Certain paintings attest this. Look
back to the first chapter at the apparent idyll of *A Very Dangerous Beach* and
one senses how the women have taken a wrong turn, and that the men have
been waiting for them. There is an insistent undertone in this and in most
Vettriano paintings, and it's this: be on your guard.

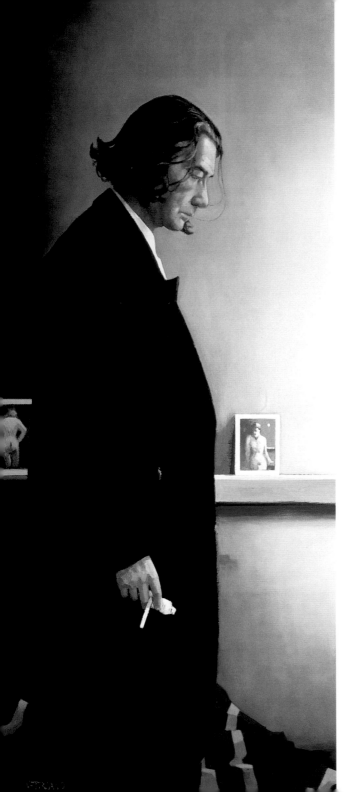

BLACK FRIDAY

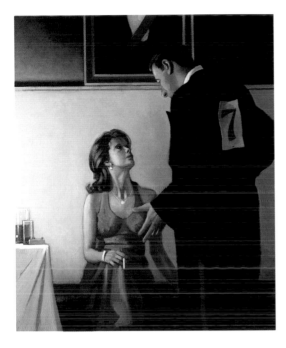

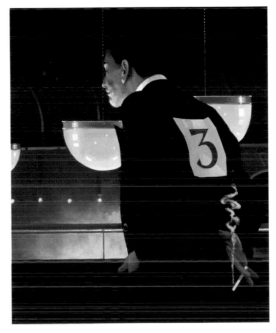

DEFENDING CHAMPIONS THE BALLROOM SPY

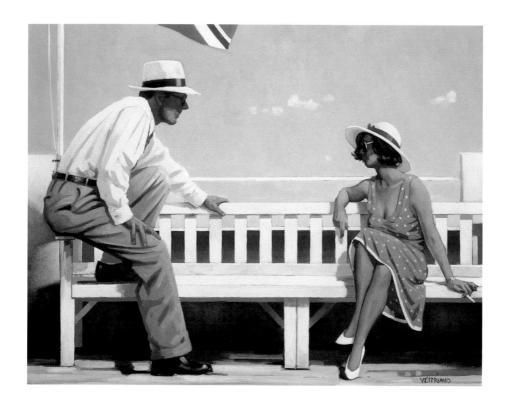

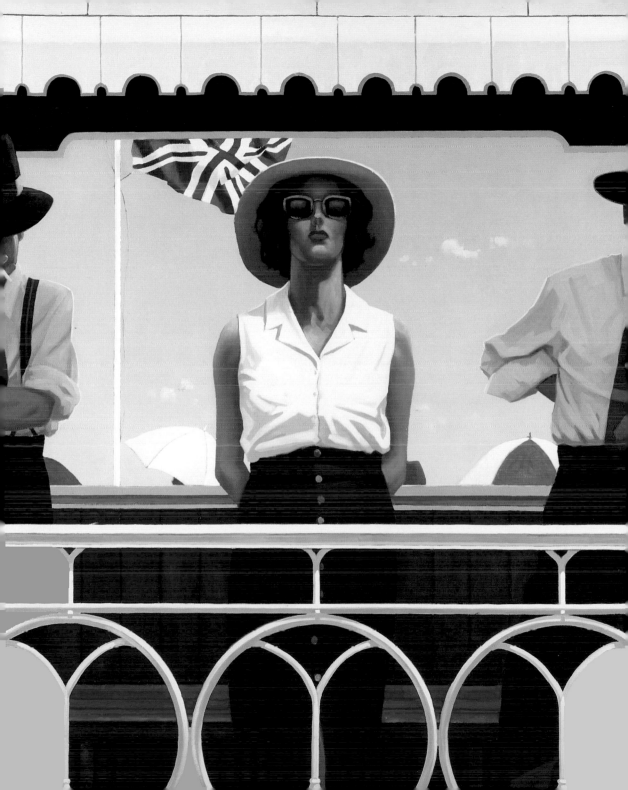

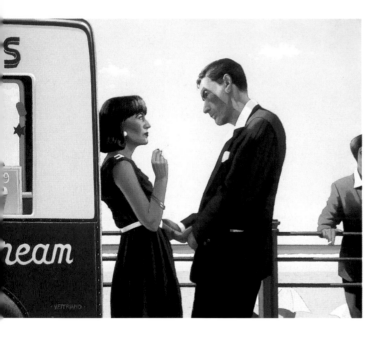

THE LYING GAME

THE MAN IN THE NAVY SUIT

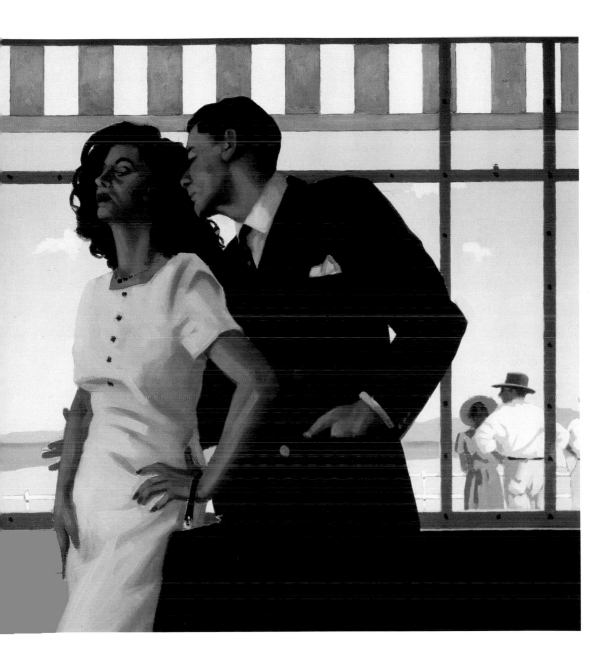

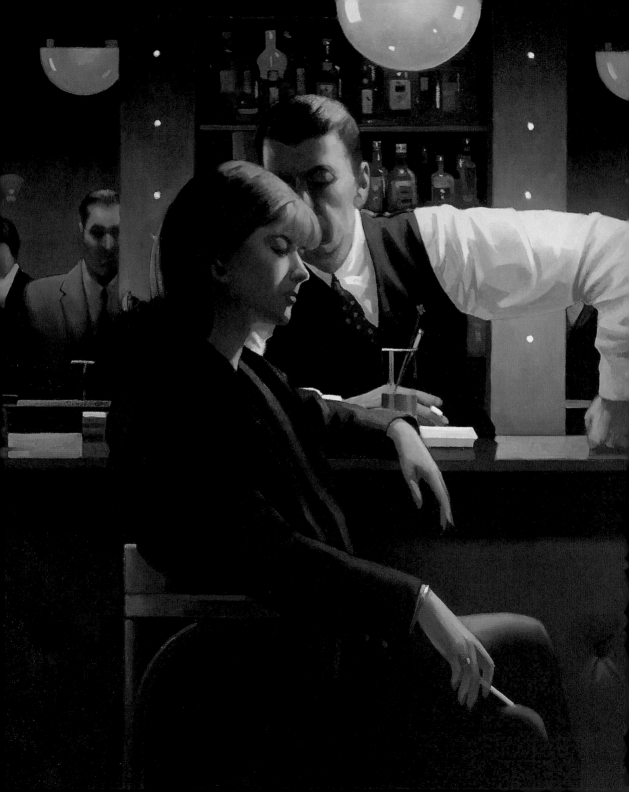

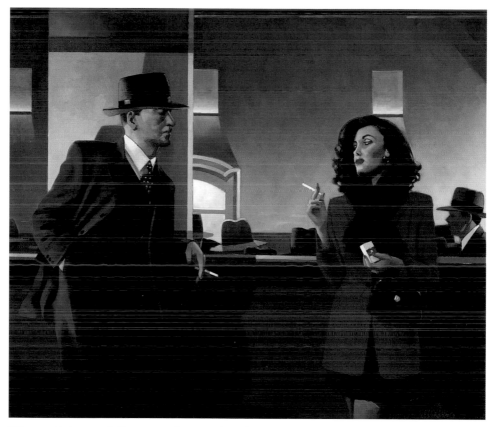

"The people in my paintings are unhappy and want someone to change them. There is that feeling that the night is simply too long and they don't want to sit at home watching TV, so they go to bars and seek out that person and end up in bed with someone they don't care for, just for comfort."

JACK VETTRIANO

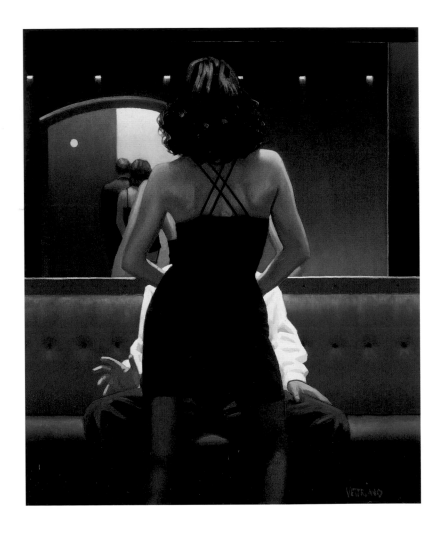

PRIVATE DANCER THE PURPLE CAT

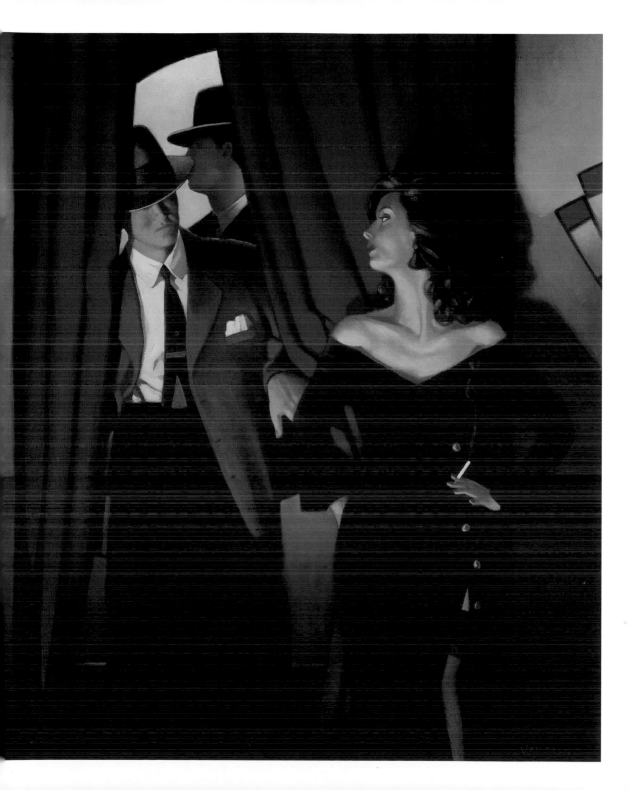

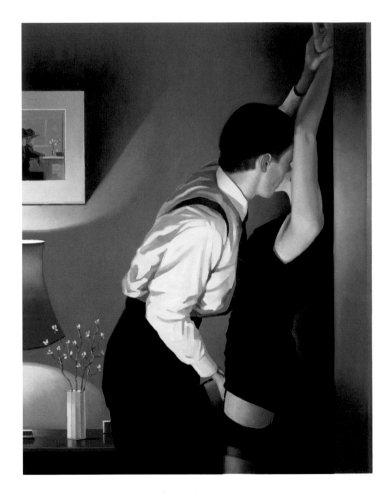

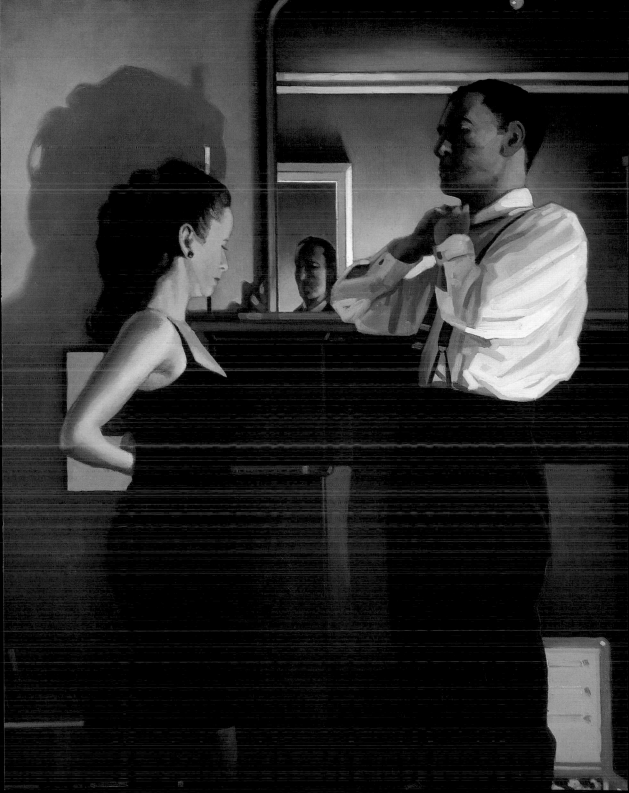

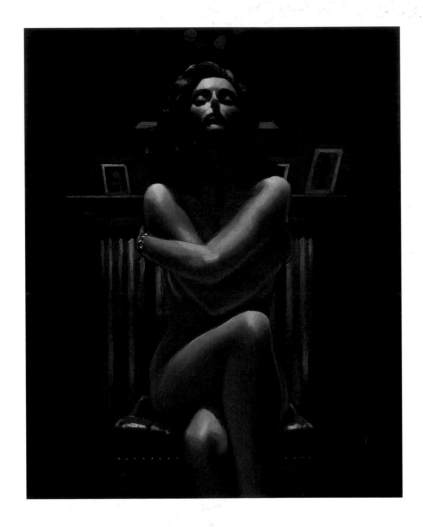

JUST THE WAY IT IS

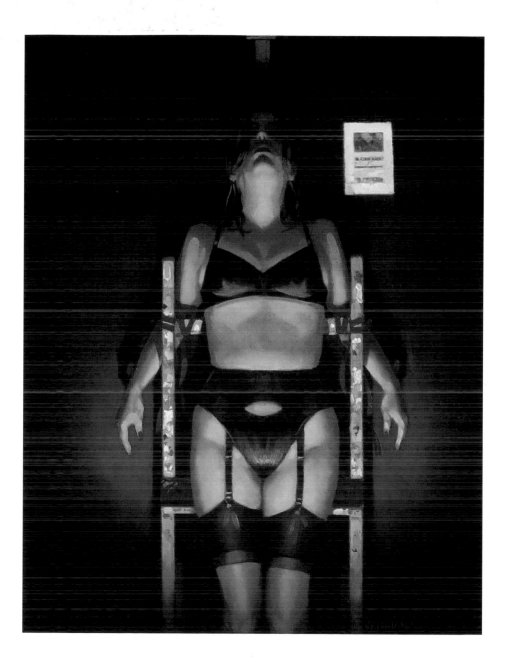

SCARLET RIBBONS, LOVELY RIBBONS

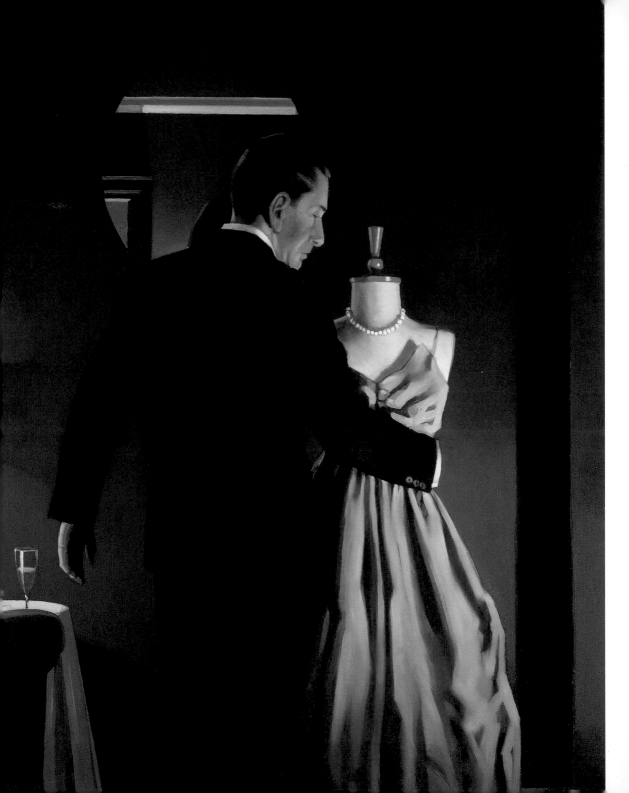

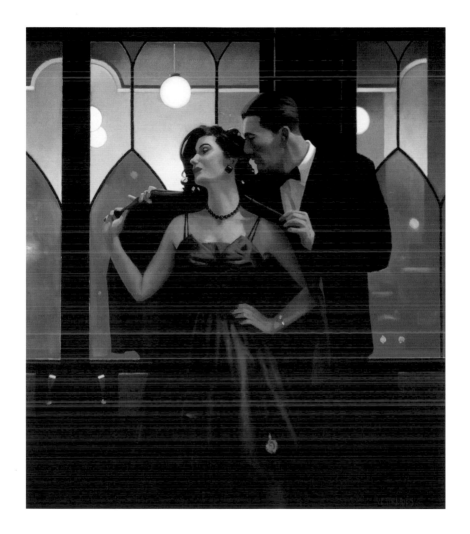

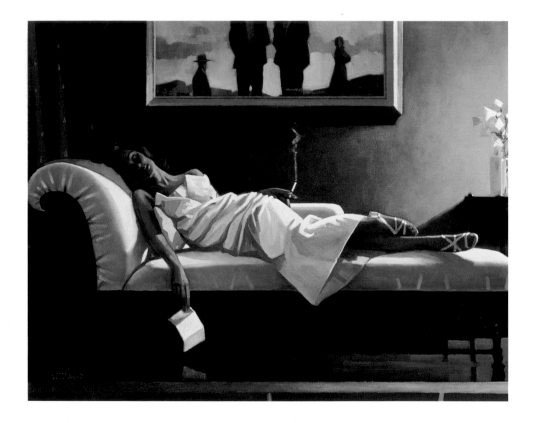

THE LETTER

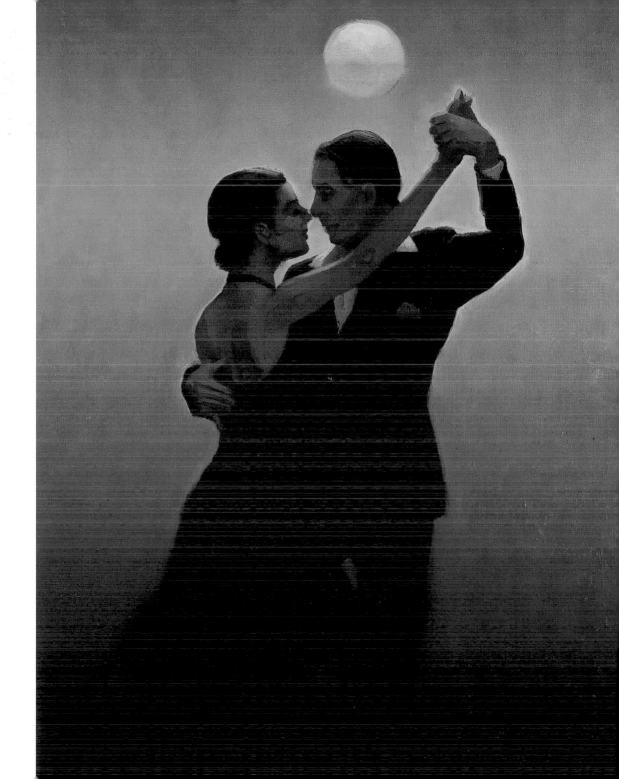

PORTRAIT IN SILVER AND BLACK

DANCE ME TO THE END OF LOVE

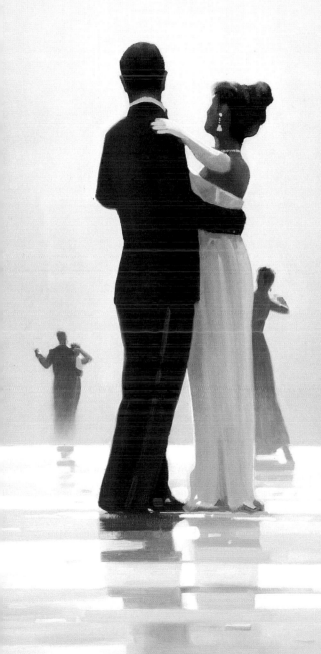

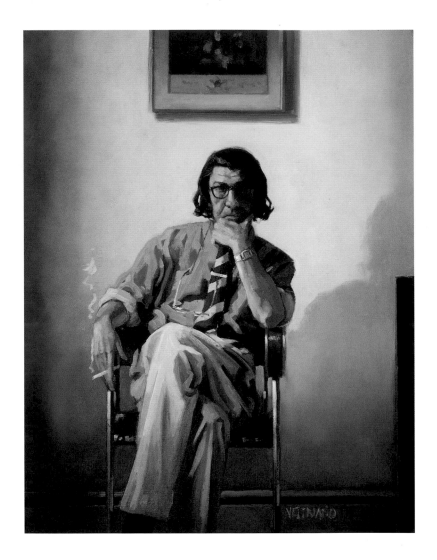

SELF PORTRAIT

SILHOUETTE

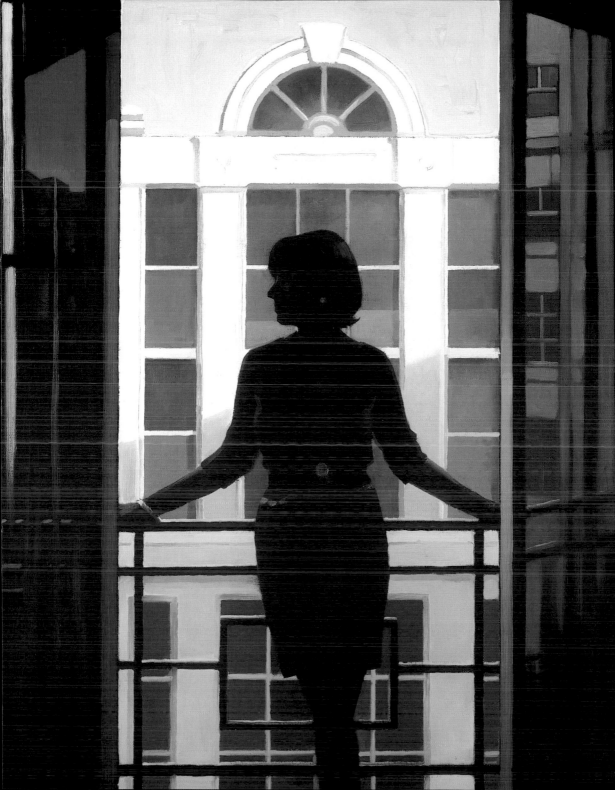

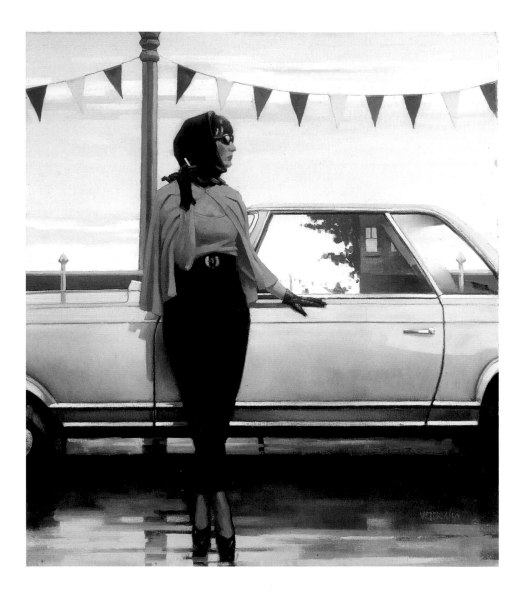

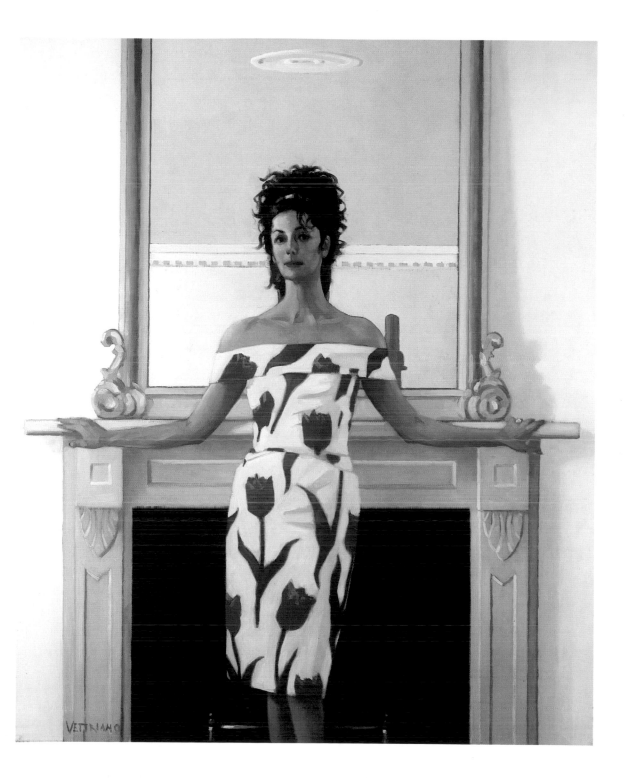

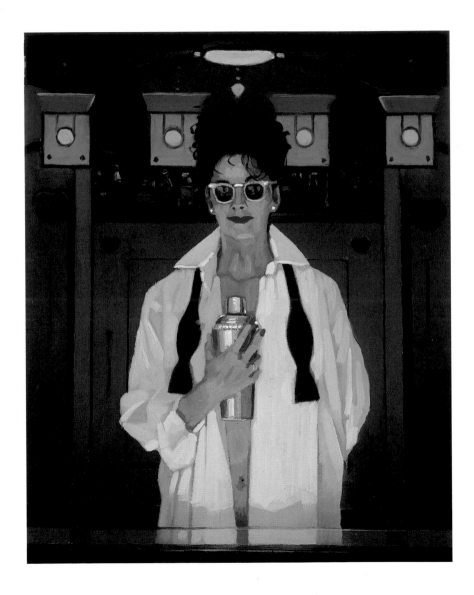

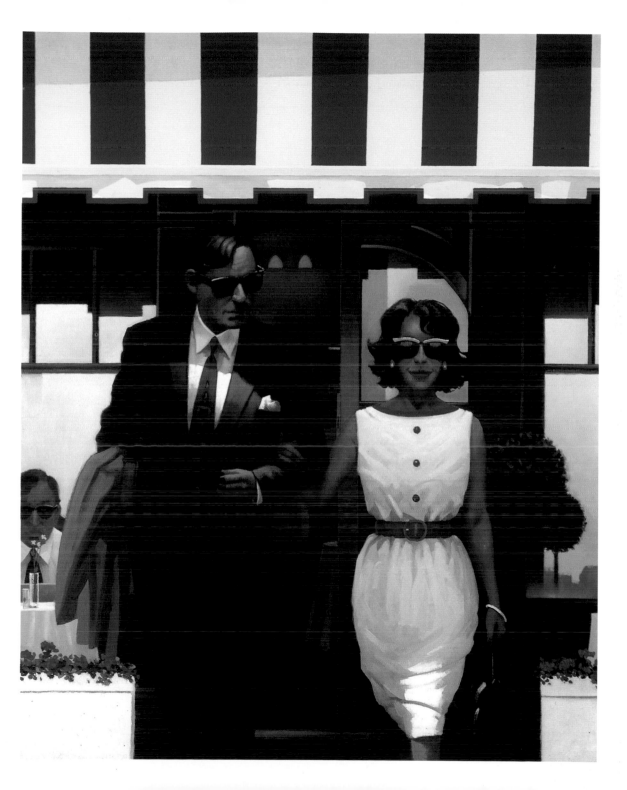

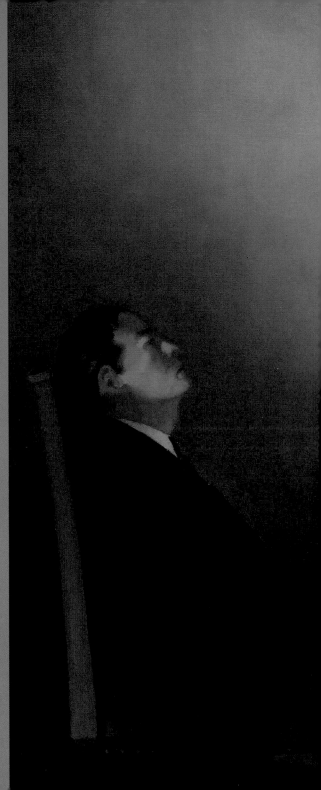

"There's a terrific frisson in many of his paintings. I love the narrative detail, the way in which you form an impression at first glance that is revised and undermined as you take in the detail."

SIR TERENCE CONRAN

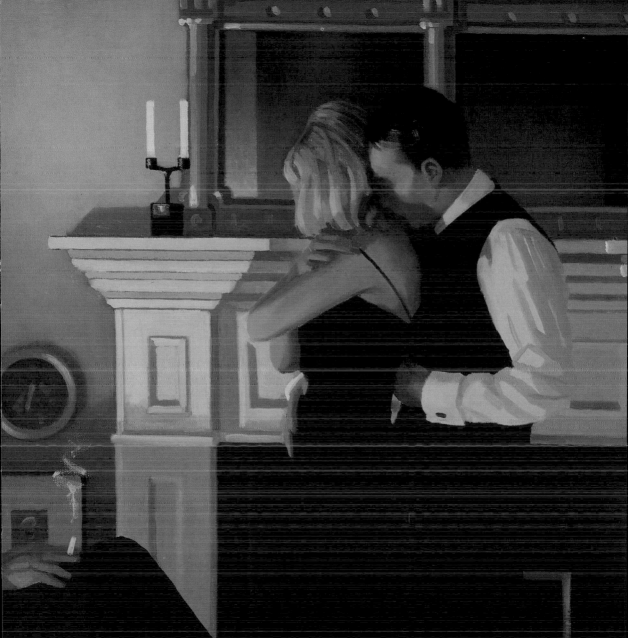

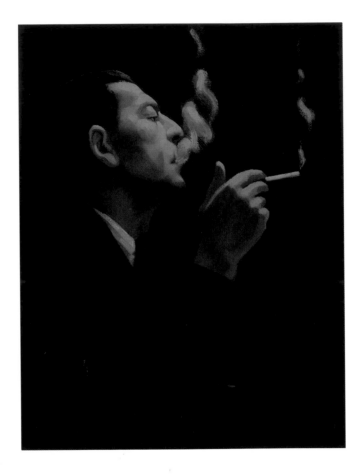

FETISH (STUDY)

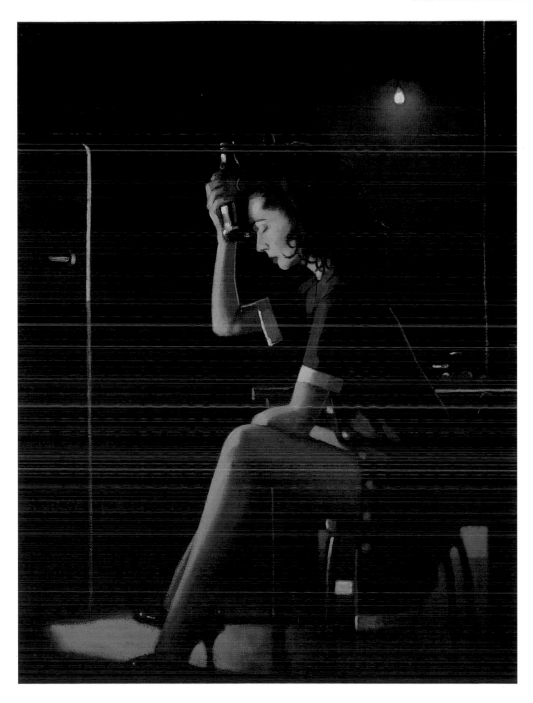

HEATWAVE

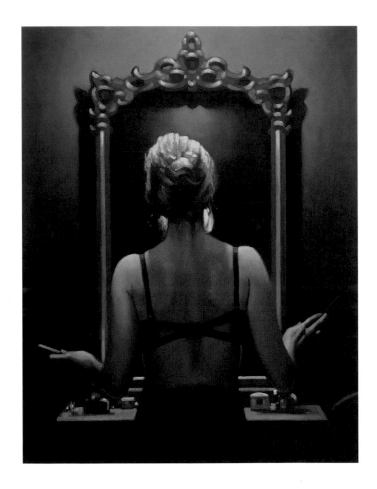

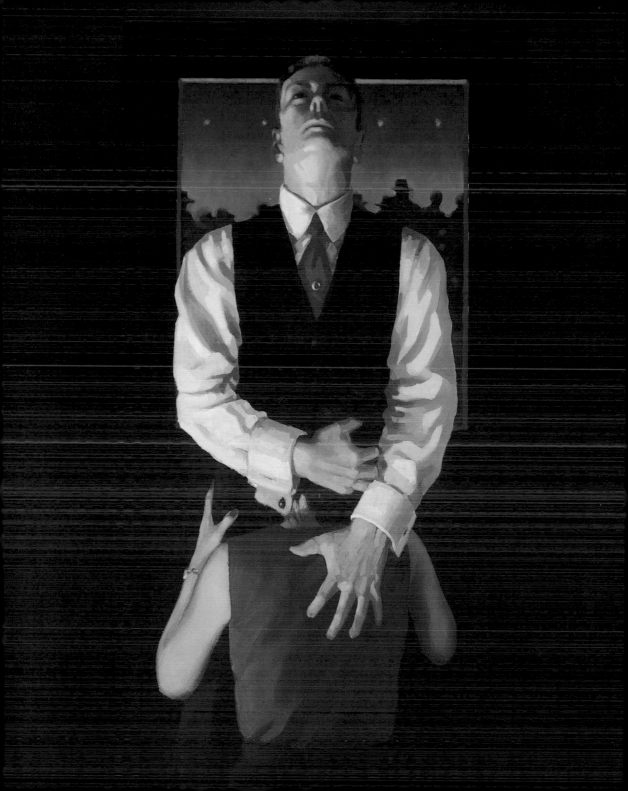

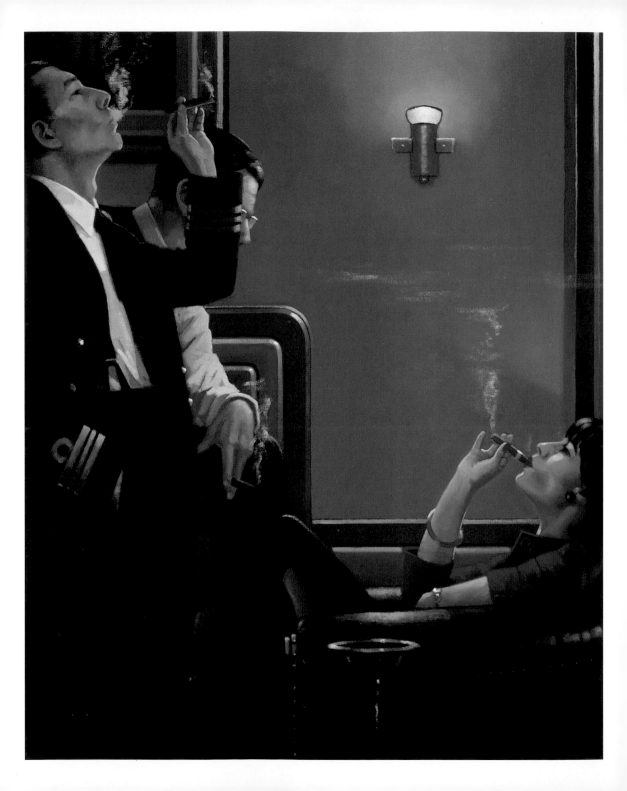

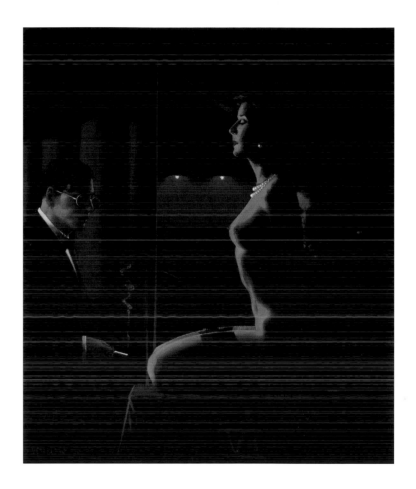

THE CIGAR DIVAN THE ASSESSORS

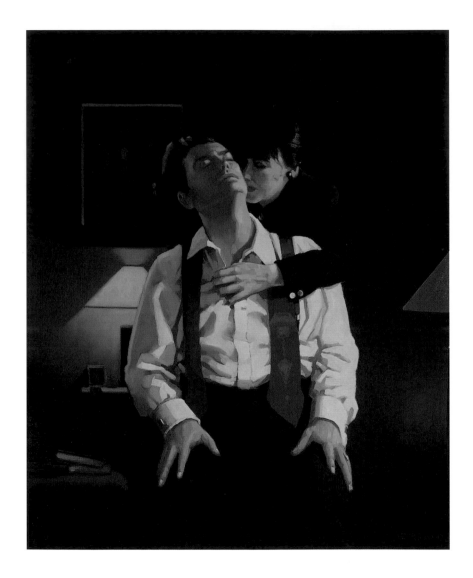

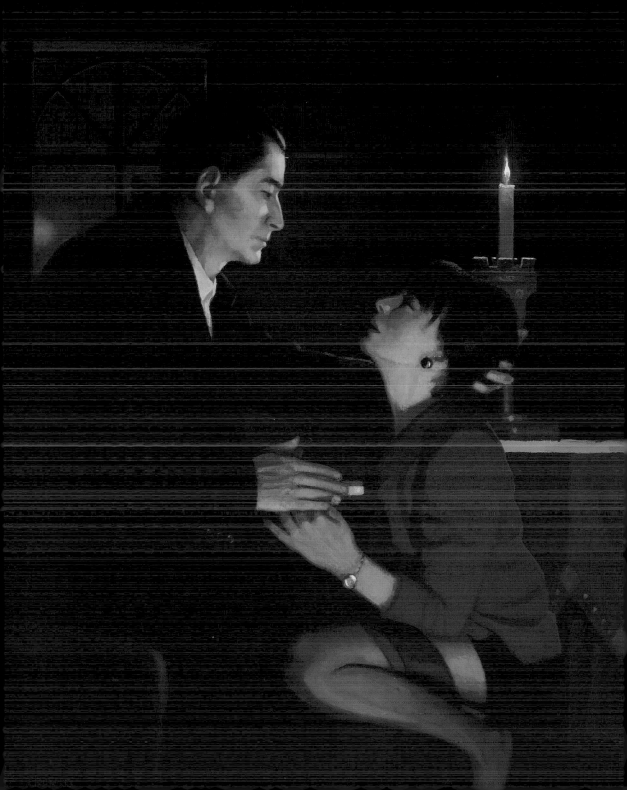

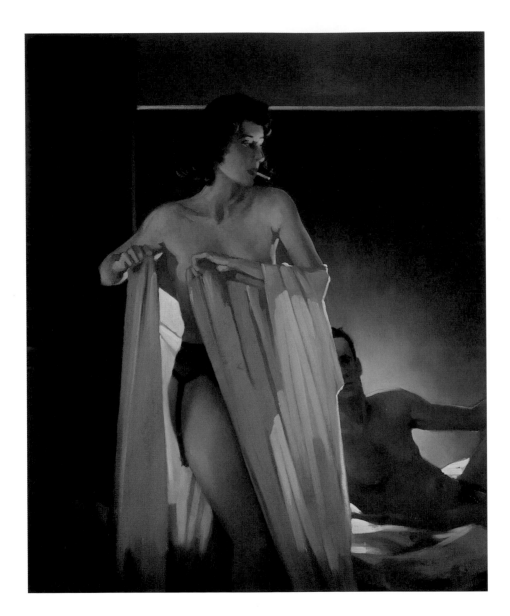

UNDER COVER OF THE NIGHT

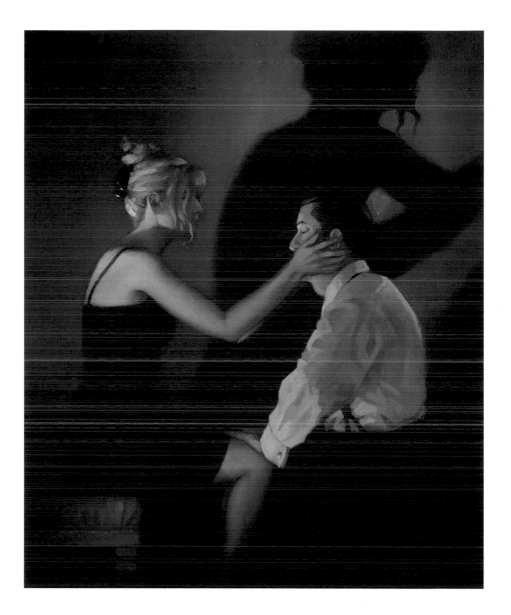

AT LAST, MY LOVELY

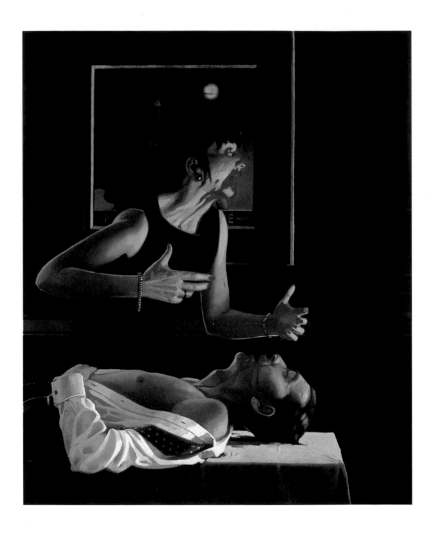

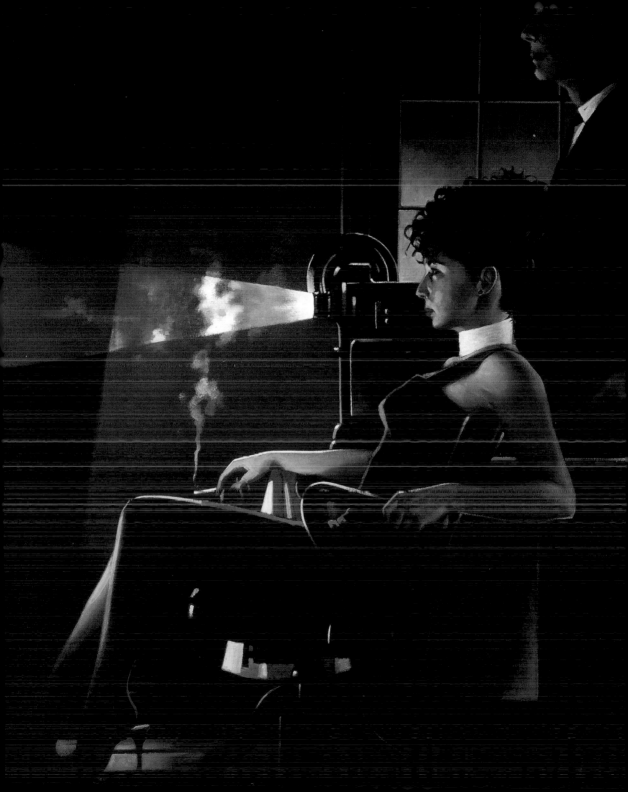

AFFAIRS OF THE HEART
2001 – 2004

As Sue Lawley's guest on Radio 4's *Desert Island Discs* in March 2004, Vettriano nominated as his favourite of the eight songs he had chosen Bob Dylan's *Like A Rolling Stone*."Dylan was the first musician whose work touched me and made me think about what he was saying. I've always loved that line 'You used to ride on the chrome horse with your diplomat'. Who would think to call a car a 'chrome horse'? I just thought it was poetry." He also cites *Tangled Up in Blue*, the opener on Dylan's magisterial album of break-up and loss, *Blood on the Tracks*, as a song he listens to constantly. "There are so many lines in that song where you think, 'That's a painting'."

Music has been a consistent influence on Vettriano's work. In his studio dozens of CDs lie scattered on the floor: he listens while he paints. Look back at the titles of his 1996 show at the Portland – *Shades of Scarlett, Edith and the Kingpin* and *A Woman Must Have Everything* – and you know immediately that his preferred listening at the time was Joni Mitchell's 1975 album *The Hissing of Summer Lawns*. Yet perhaps even closer to his heart than Dylan and Mitchell is that troubadour of melancholy, Leonard Cohen, whose music is as much a fixture as easel and canvas *chez* Vettriano. The Cohen album *Death of a Ladies' Man* is his current favourite: "I'm sure there are things in those songs that will come out in the next exhibition. There's an image turning over and over in my head at the moment - 'The walls of this hotel are paper-thin/ Last night I heard you making love to him'. I can imagine a sinister-looking picture of a man with his ear cocked, staring into the middle distance and concentrating on what he's listening to." The lines might almost have been written for him: eavesdropping is a compulsive pursuit in Vettriano's lowlit, late-night world.

In June 2004 his first new paintings in four years, *Affairs of The Heart*, were exhibited at the Portland. The show contained many signature Vettriano images – *Along Came A Spider, Soho Nights* and *A Letter of Consequence* – and one or two more surprising pictures, such as *Just Another Day* where a contemporary London background offsets the 1920s' look of the woman in a

red cloche hat. The promenade spy in *Jealous Heart* derives from a holiday in Nice. Something else is new. Traditionally Vettriano would be the model for his own paintings, reasoning that he could keep things discreet – and he was free. Now a younger man models in the pictures, for a simple reason: "I'm beginning to look too old. I don't want people to look at the paintings and wonder who's the lecherous old devil with this young girl."

The prices in the latest show are also pushing into new territory. The sale of *The Singing Butler* has sent Vettriano's stock skyrocketing, and the time may have come when his work is affordable only to serious collectors. Sotheby's is putting a high estimate on it, and the next sale at Gleneagles will feature a separate Vettriano catalogue. Yet as his name has acquired a lustre, the man himself remains determinedly realistic, even modest, about his worth. "I know that *The Singing Butler* is not the best painting in Scotland, by a long chalk. It's just a curious phenomenon. All you need is two guys in a sale room outbidding one another. That doesn't make it an exceptional painting".

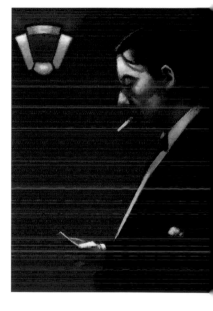

While one would hesitate to call him happy, Vettriano has much to be pleased about. It isn't simply his properties in Oxford and Kirkcaldy, his flat in Knightsbridge or his vintage Mercedes. It's more to do with having enough money to give away. He recently set up a bursary at St.Andrews University to subsidize students who might otherwise be unable to support themselves. Yet even this largesse is clouded with remorse. "I give material things because it compensates for not being able to give my time, or share my feelings very easily. I can't have people around if I'm not giving to them – I feel too guilty." The desire to paint spurs him on, yet success brings its problems. While he can handle the pressure of work, he finds the pressure of personal invasion much trickier, and now that he is a valuable commodity, media interest in his life will only intensify. For someone as pathologically private as Vettriano this is bad news, but he'll survive it. Like those dark suited lovers and strangers he paints, he knows a thing or two about keeping to the shadows.

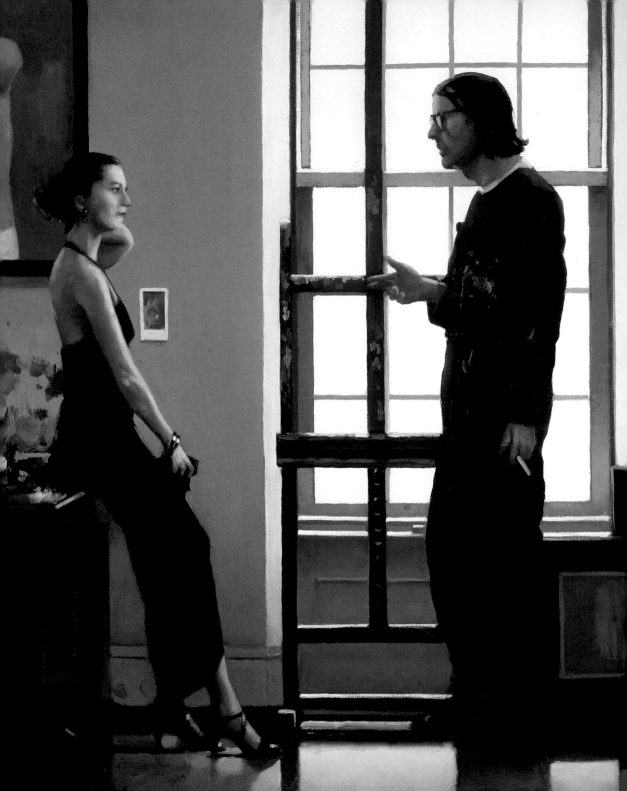

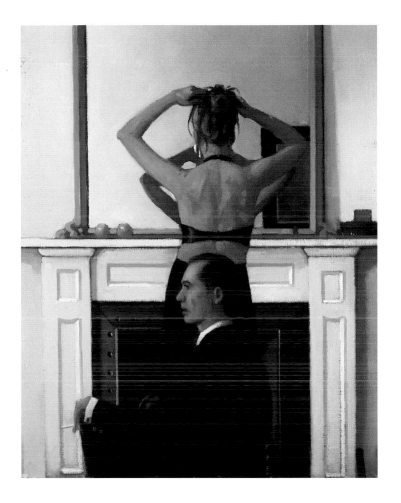

ARTIST AND MODEL

MODELS IN THE STUDIO (STUDY)

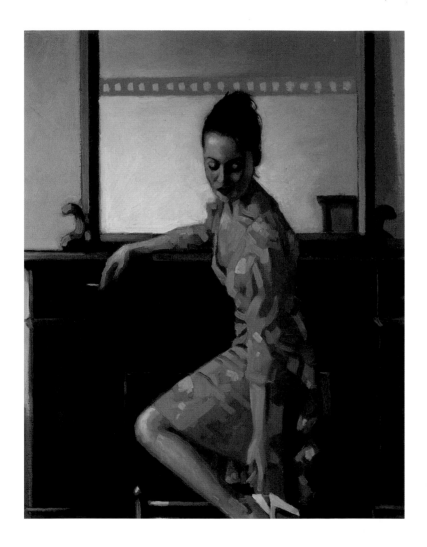

MODEL IN WESTWOOD ONLY THE DEEPEST RED II

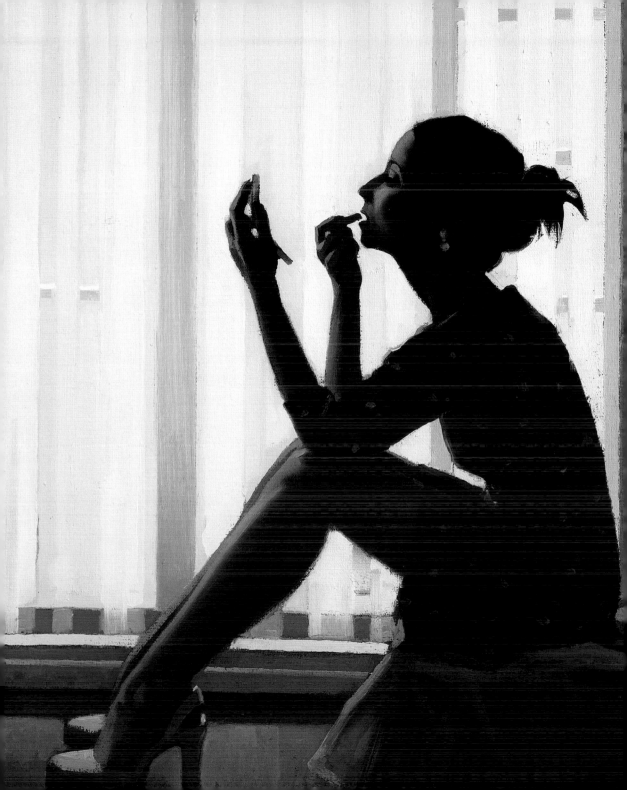

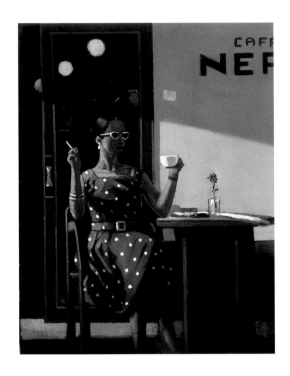

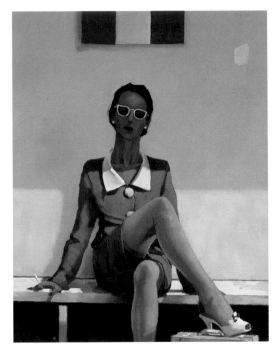

THE ICE MAIDEN

THE TOURIST

TENDER HEARTS

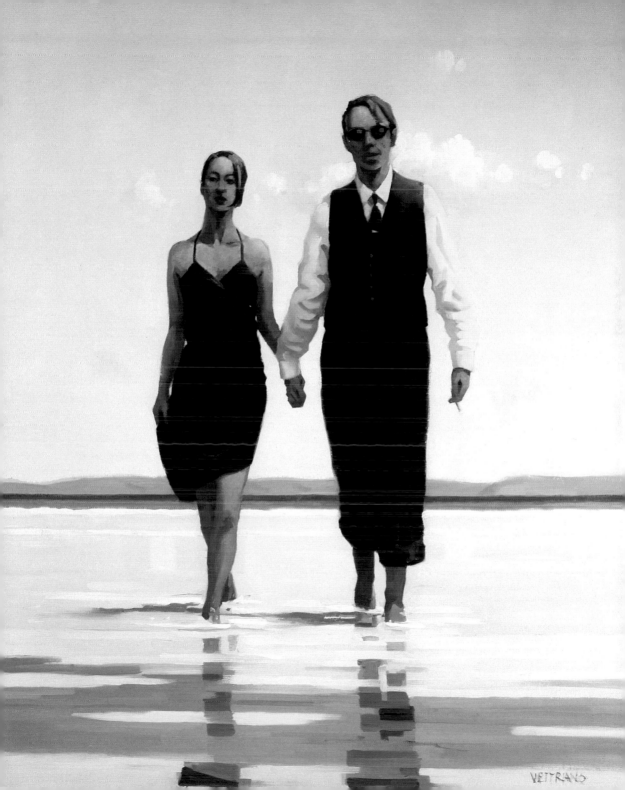

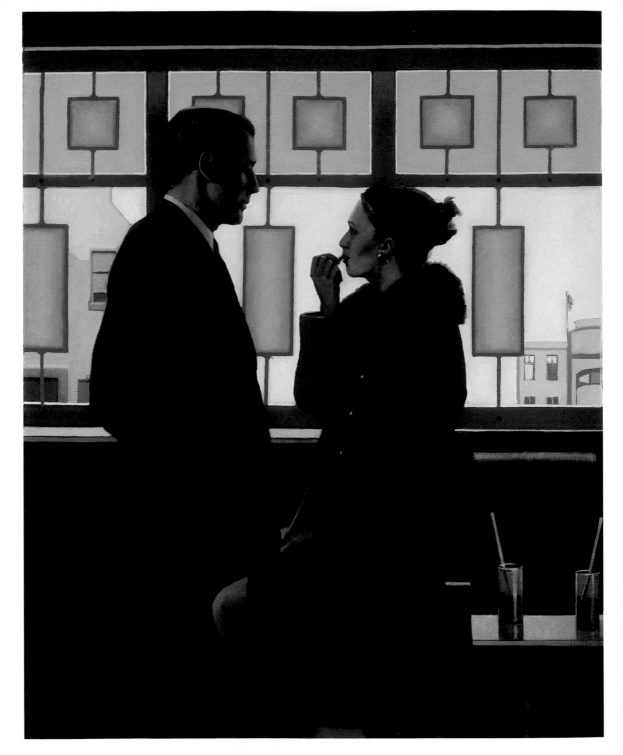

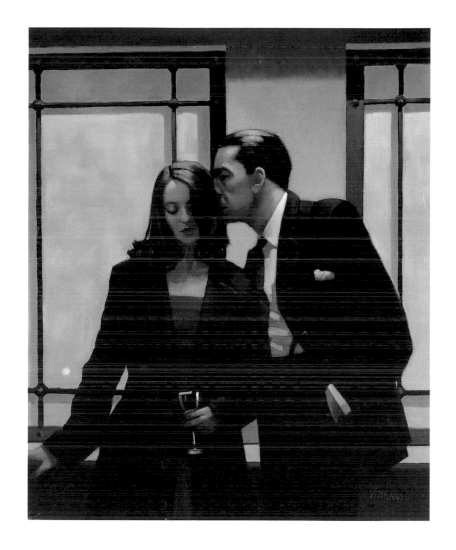

DRIFTERS CONTEMPLATION OF BETRAYAL

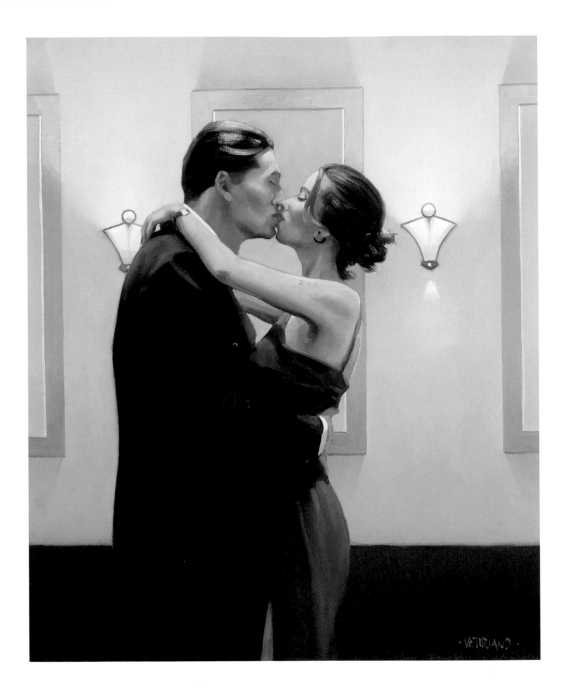

BETRAYAL - THE FIRST KISS

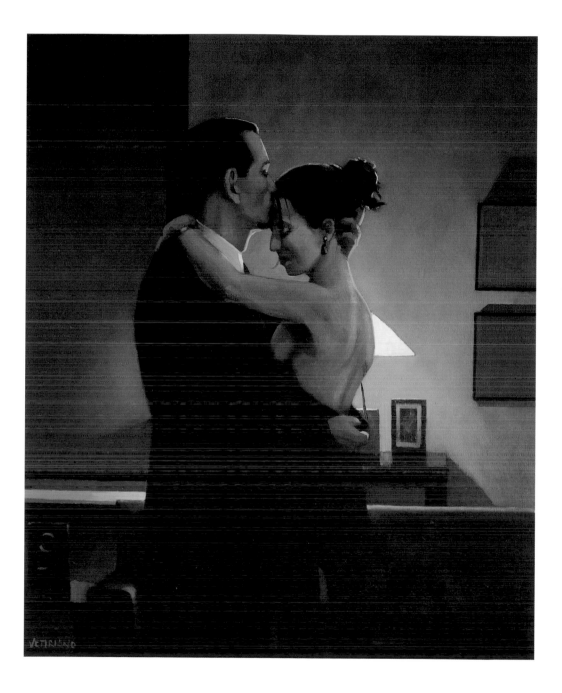

Betrayal - No Turning Back

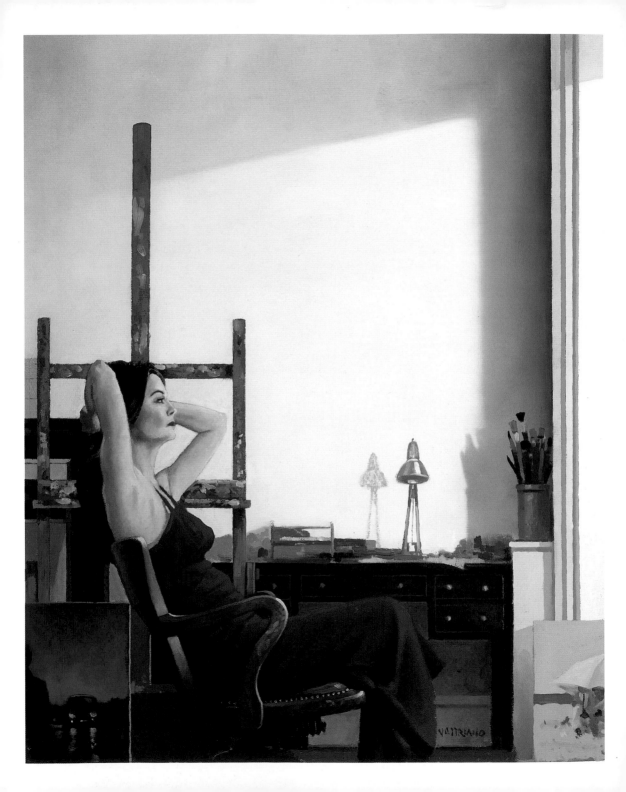

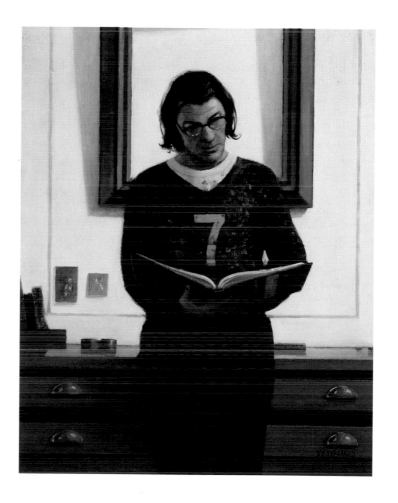

STUDIO AFTERNOON LUCKY SEVEN

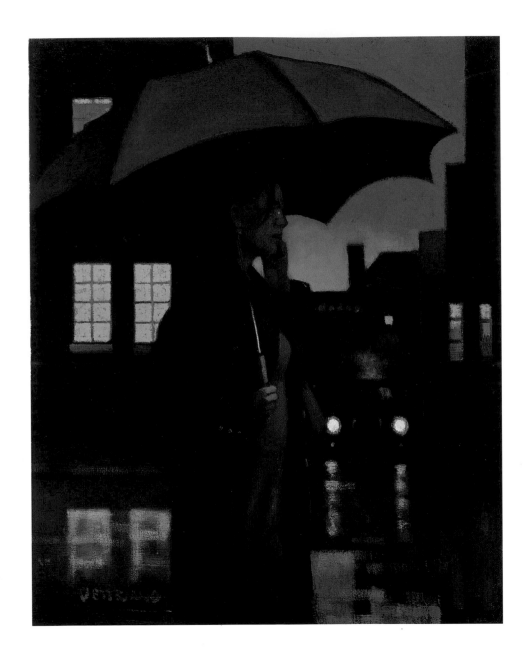

ALL SYSTEMS GO

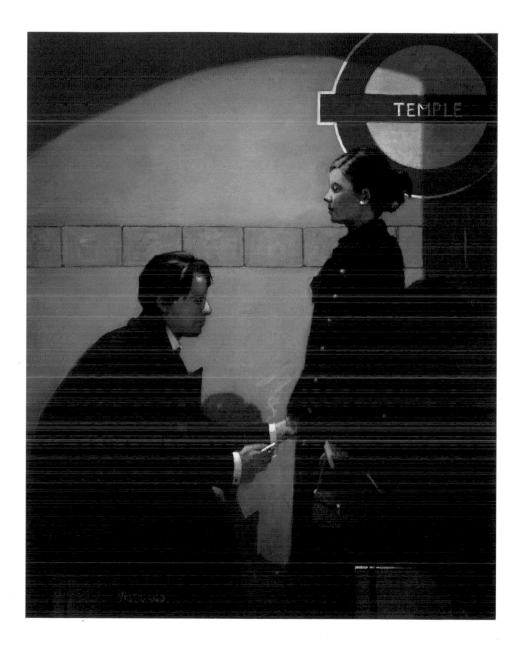

THE RUNAWAYS

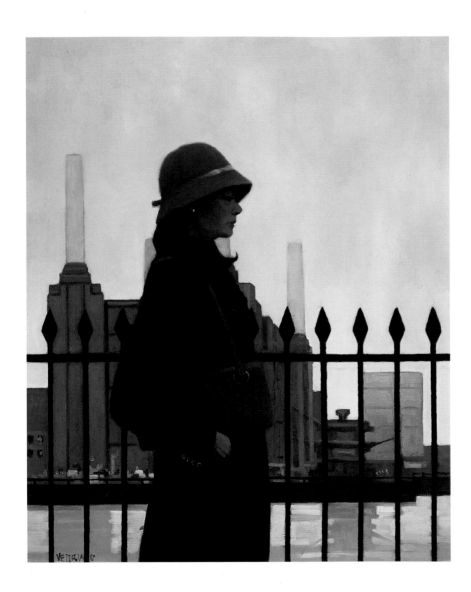

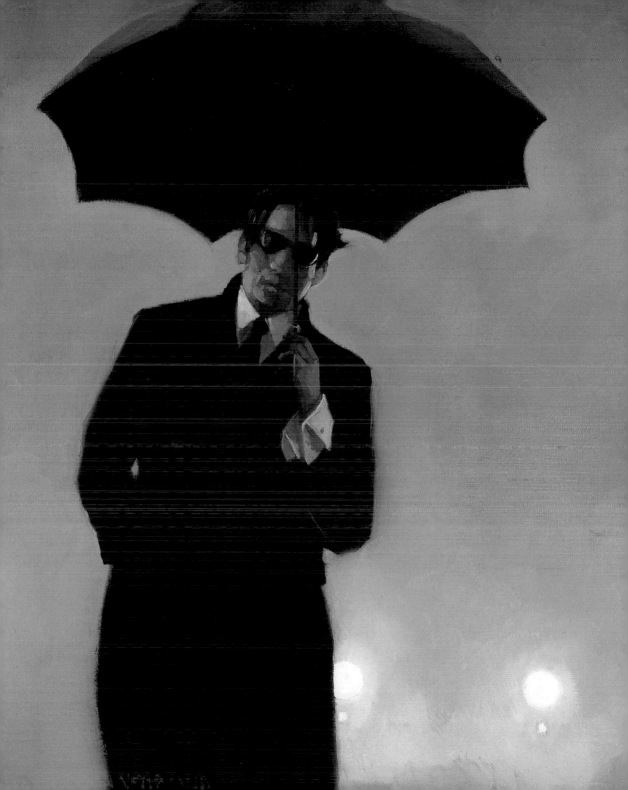

"In this game of love, women
have immense power ... much
more power than we [men] do.
The aim is to show the way they
can really tie us up in knots.
We're animals in comparison."

JACK VETTRIANO

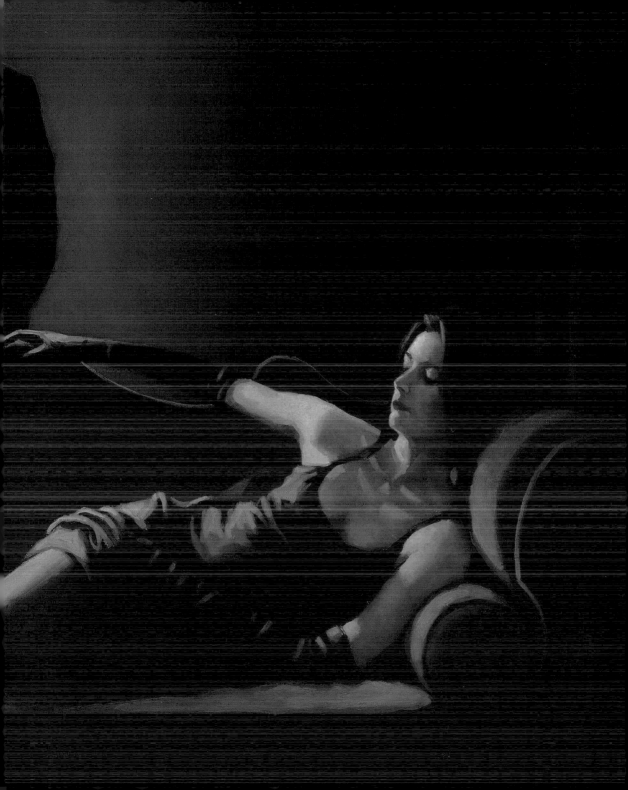

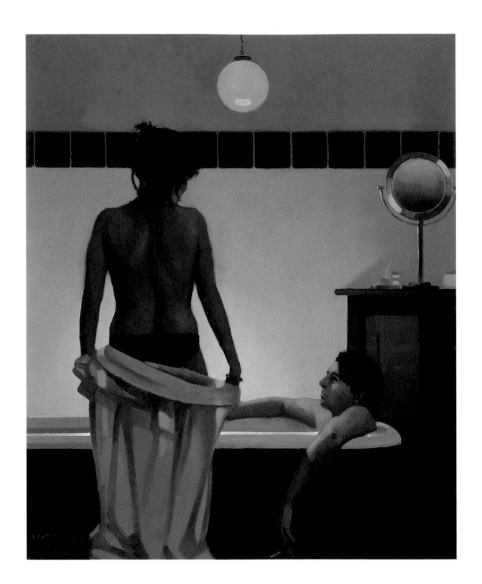

THE WATER BABIES

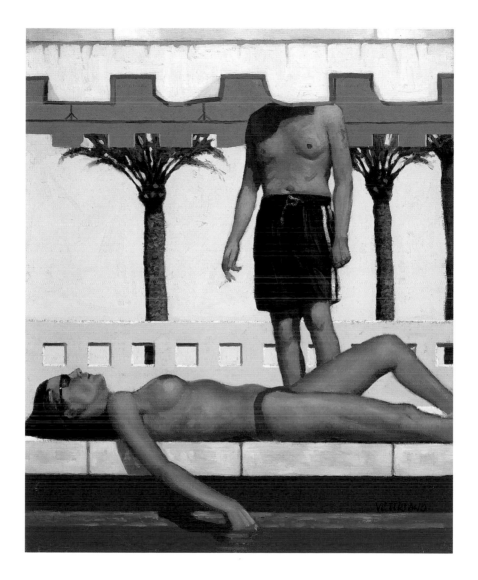

AN UNINVITED GUEST

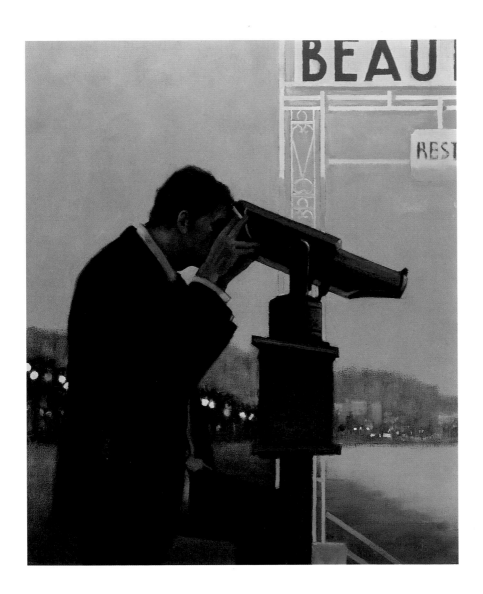

JEALOUS HEART

BABY, BYE BYE

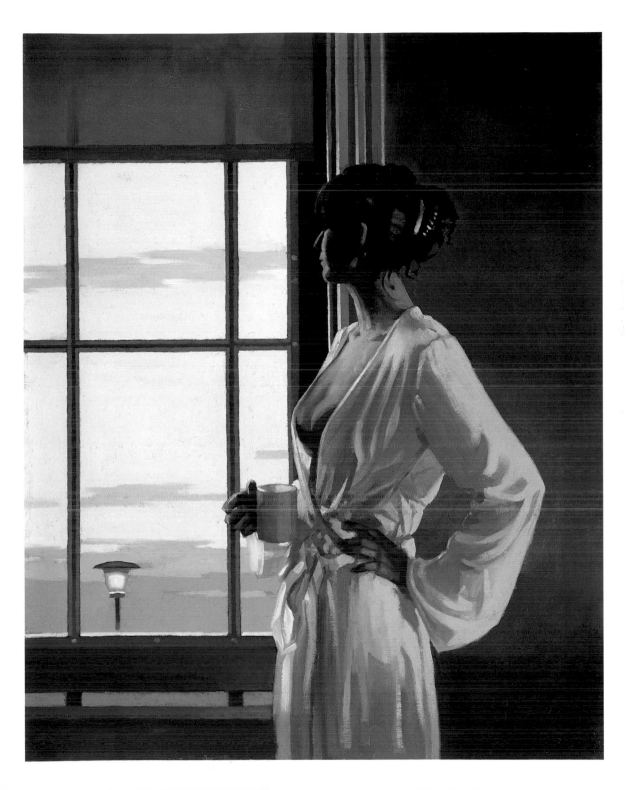

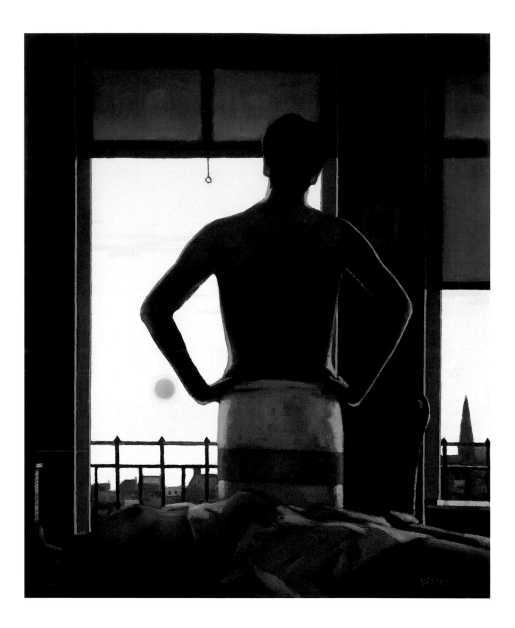

THE REMAINS OF LOVE

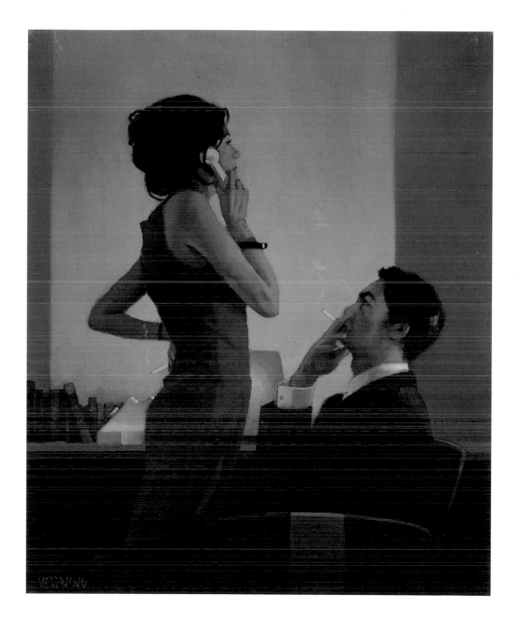

THE SET UP

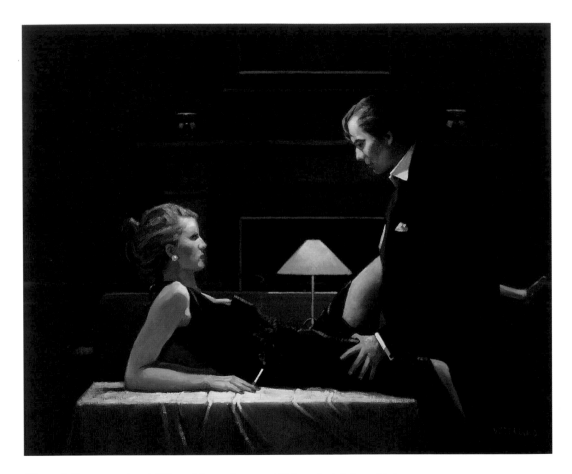

"My paintings are about things I have done and things I wish I could do.

They are about a bunch of sad, unhappy people who are driven by lust."

JACK VETTRIANO

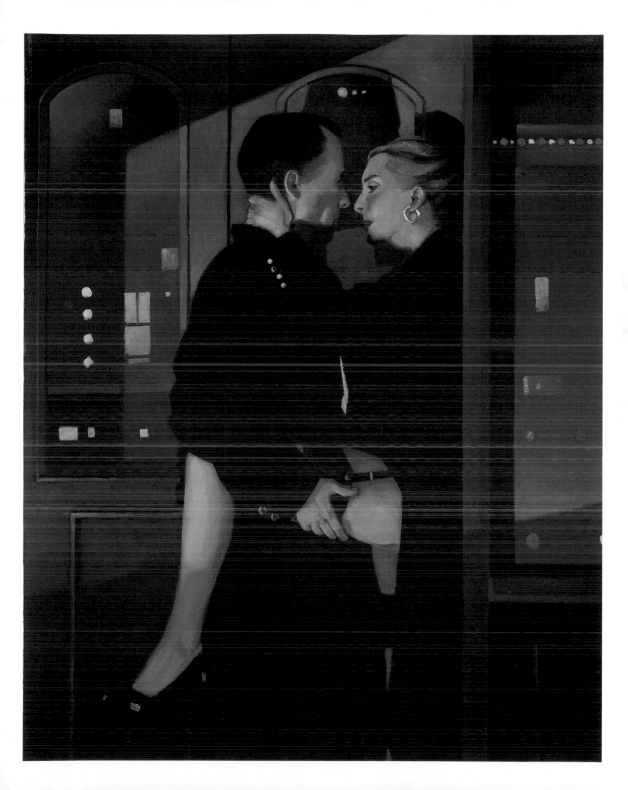

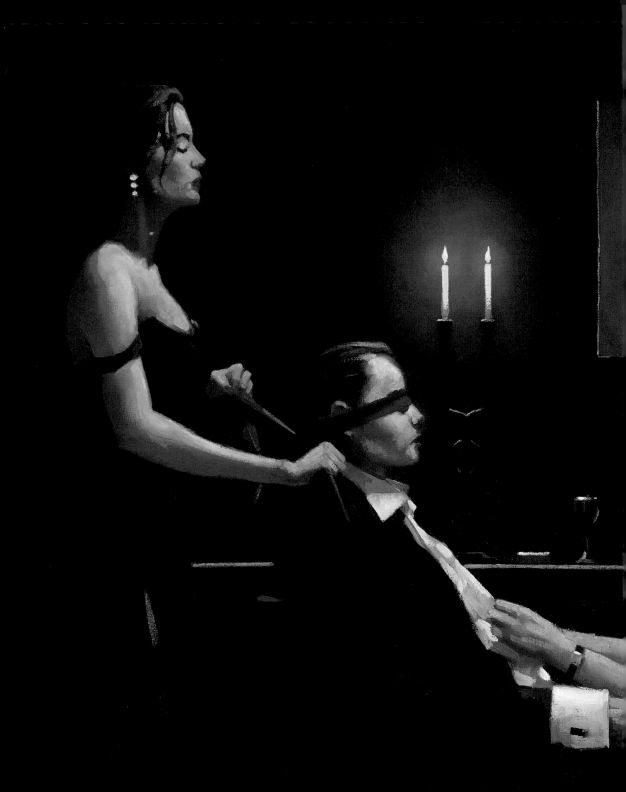

MIND BENDING (DETAIL)

WICKED GAMES

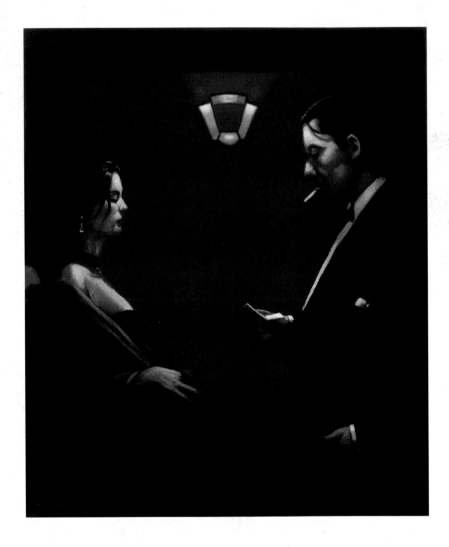

A LETTER OF CONSEQUENCE

THE EMBRACE OF THE SPIDER

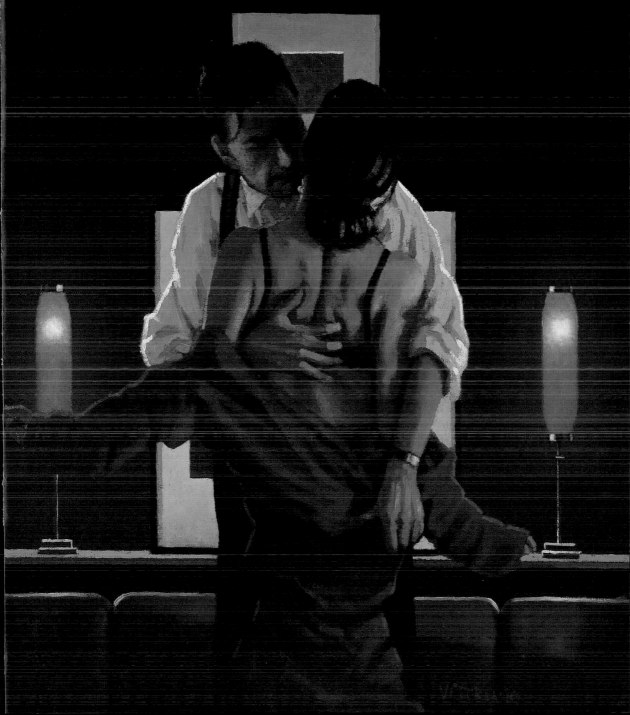

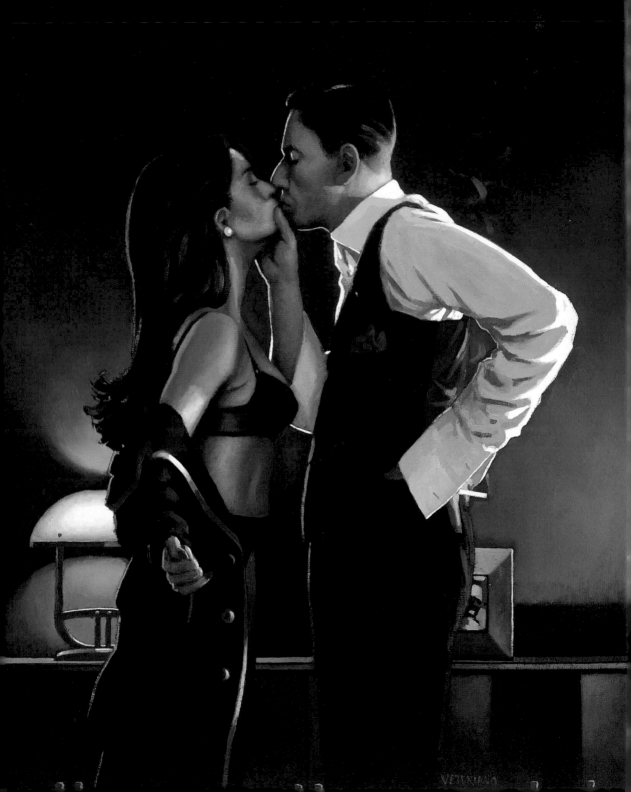

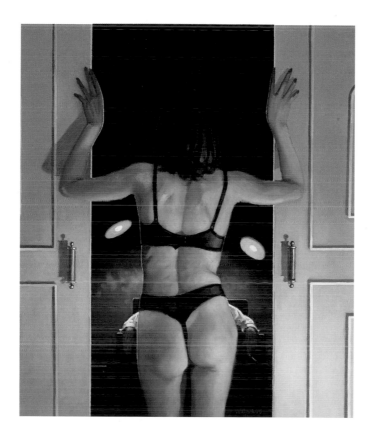

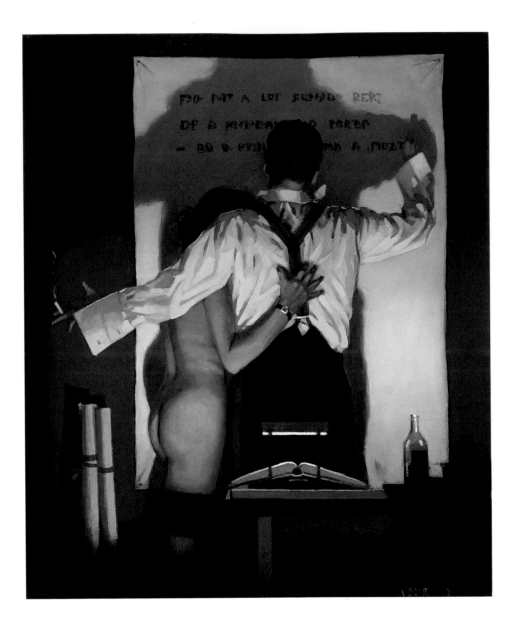

THE GREAT POET

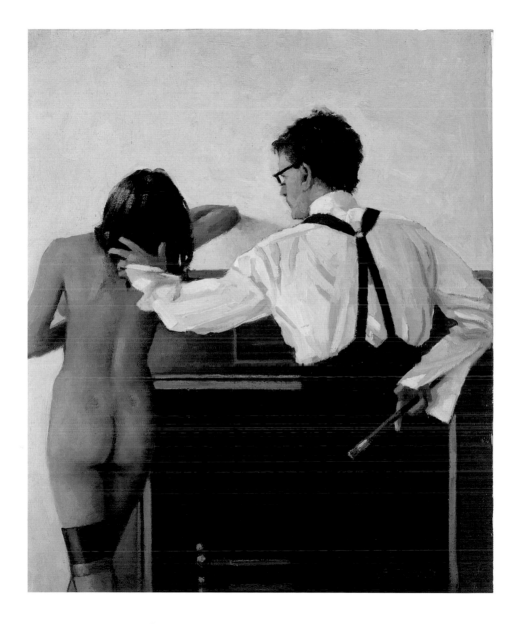

REACH OUT AND TOUCH

EXHIBITIONS AND PAINTINGS

1992
TALES OF LOVE AND OTHER STORIES

Amateur Philosophers
A Test of True Love
A Kind of Loving I
A Kind of Loving II
A Kind of Loving
Contemplation of Betrayal
Betrayal, the First Kiss
Betrayal, No Turning Back
Sweet is the Night
Queen of the Fan-Dan
The Picnic Party
The Heat of the Day
Waltzers
You Can't Come to this Party!
A Very Dangerous Beach
Incident on the Promenade
Ae Fond Kiss
Ghosts From the Past
The City Café
The Tattooed Lady
Young Turks
Homage to Albert Vargas
Model in Black
Hope and Glory
The Star Café
The Obsessive Collector
The Flirtatious Woman
The City Café I
A Test of True Love I

The Model and the City Boy
The Last Letter
Room 6, the Purple Cat
And Waiting Still
Ae Fond Kiss I
Gamblers
Crime Passionel

1992
GOD'S CHILDREN

Angel
Ritual of Courtship
Narcissistic Bathers
Strangers in the Night
Fair Exchange is No Robbery
Candy and Mr. Smith
Another Kind of Love
Mad Dogs
The Singing Butler
The White Slip
Model in Black
Evening Racing
Busted Flush
The Star Café
Cleo and the Boys
Big Bert's Favourite Girl
The Unorthodox Approach
The Gathering Clouds
Dream Lover
Heartbreak Hotel

1993
FALLEN ANGELS

Footprints in the Sand
A Seaside Shark (study)
Betrayal: No Turning Back (study)
The Live Art Show
The Waiter and the Wife
A Voyage of Discovery (study)
Busted Flush
Evening Racing
Cleo and the Boys
The Star Café
The First Audition
The Stripper
Working the Lounge
Miss French in Her Parlour
The Strange Case of Mr Moonlight
Just Another Saturday Night
Sometimes it's a Man's World
Cheating Hearts
Night Negotiations
Neutral Territory
A Voyage of Discovery
Setting New Standards
Sailor Boys
A Couple of Swells
Portrait of the Artist (study)
Fixing the Rate (study)
Cleo and the Boys (study)
Couple on a Promenade (study)
Night Negotiations (study)

1993
SUMMERS REMEMBERED

The Duellists
Model in White
Dancing Couple
The Main Attraction
Good Time Girls
Seaside Sharks
The Innocents
The Barmaid's Fancy
Busted Flush
A Covert Proposition
The Insiders
Model in White (study)
Summertime Blues (study)
Gambling Boys
A Date with Fate
The Same Old Game
The Direct Approach
The Administration of Justice
Summertime Blues
The Mad Hairdresser (study)
Right Time, Right Place
Summer Love (study)
Drifters (study)
The Same Old Game (study)
The Duellists (study)

1994
CHIMES AT MIDNIGHT

Sweet is the Night
The Drifter
The Defenders of Virtue
We Can't Tell Right from Wrong
Self Portrait
The Same Old Game
A Bad Bet
Heaven or Hell
After the Thrill is Gone
Elegy for the Dead Admiral
Midnight Blue
The Shape of Things to Come
And Waiting, Still
A Mutual Understanding
The Innocents
The Billy Boys
The Night Watchmen
A Mutual Understanding II
Woman Pursued
The Master of Ceremonies
The Opening Gambit
Yesterday's Dreams
Bad Boy, Good Girl
The Scorpio Club
The Apprentice
The Tourist Trap
Kings for Two Summers
Heartbreak Hotel
Bad, Bad Boys
Rosie Oh Rosie

How the Web is Woven
A Beach Boy
Happy Hour
The Trap
Model in Black
And Some, They Never Do
The Fixer
Woman in a Bar
Man in a Bar
The Billy Boys (study)
The Defenders of Virtue (study)
Yesterday's Dreams (study)
Back to Basics
A Bad Bet (study)
Man of Ritual
Visiting Angels
The Opening Gambit (study)
We Can't Tell Right from Wrong (study)

1995
A DATE WITH FATE
The Sparrow and the Hawk
Baby Blue
Bad Timing
The Man in the Mirror
No Safety in Sunshine
The Perfectionist
How Do You Stop?
The Model and the Drifter
Heaven or Hell: The Sweetest Choice
Self Portrait with Carnation
On the Border

Something in the Air
Portrait in Red, Black and Blue
Dressing to Kill
Café Days
Someone Else's Baby
Sweet Bird of Youth
Ties that Bind
Gentlemen in Waiting
The Perfect Ring
Cold Cold Hearts
Portrait in Black and White
We Can't Tell Right from Wrong
Formal in Stockbridge
The Twilight Zone (study)
The Altar of False Hope
Self Portrait: Man at Work
Portrait in Black and White (study)
Silhouette: Afternoon Tea
The Headless Man
The Voyeur
Gentlemen in Waiting (study)
The Perfectionist (study)
Self Portrait with Easel
How Do You Stop? (study)
Fetish
Model in Black (study)
Portrait in Red, Black and Blue (study)
Sweet Bird of Youth (study)
Heaven or Hell (study)

1996
THE PASSION AND
THE PAIN

Shades of Scarlett
The Assessment
Back Where You Belong
The Parlour of Temptation
The Big Tease
The Railway Station
The Tourist Trap
Searching the Soul
Ritual Dances
The Red Room
Edith and the Kingpin
Courting Couple
There's Always Someone Watching You
Bad Boy Blues
The Mark of Cain
Scarlet Ribbons
And So to Bed
Bar Boys
Back to Basics
Dressing to Kill
Beach Babes
The Waiting Game
Winter Light and Lavender
Self Portrait with Beret
The Party's Over
After Midnight (study)
Good Day's Sunshine
The Awful Truth
Oh Happy Day

The Road to Nowhere
One Moment in Time
A Woman Must Have Everything
Sweet Bird of Youth

1996
HALFWAY TO PARADISE

Games of Power
Railway Station Blues
Live Commentary
The Blue Gown
Portrait of the Artist
The Artist and the Model
Night Geometry (study)
The Last Great Romantic (study)
A Dancer for Money
The Rooms of a Stranger
Young Hearts
The Fine Art of Racing
Model Reclining
Table for One
Still Dreaming
Scarlet Ribbons, Lovely Ribbons
Mirror, Mirror (study)
Round Midnight (study)
Waiting and Watching
The Drawing Room
The Balcony Boys (study)
On the Border (study)
Games of Power (study)
Young Hearts (study)

The Fine Art of Racing (study)
The Nationalist
The Games Master
Lazy Hazy Days
Something in the Air
Dancer for Money (study)
Miss French

1997
SMALL PAINTINGS
AND STUDIES

The British are Coming (study)
Girls' Night (study)
Cocktails and Broken Hearts (study)
Only a Rose
Mr Cool (study)
The Cigar Girl (study)
Rough Trade (study)
Single Girl, Married Man
The Dressing Mirror
Model in Black
Singin' the Blues (study)
The Longing (study)
The Wife and the Wine Waiter
The Last Great Romantic
Waiting for Bluebird
Dancers
Shaft of Light
Self Portrait
Self Portrait II
Man on a Beach

Mad Dogs (study)
The Tango Master
Going Nowhere
Wild Thing
Man in a White Shirt
The Singing Butler (study)
Inside Information
Night in the City
Night Geometry
In Thoughts of You (study)
The Longing
Singin' the Blues
Tomorrow Never Comes

1998
BETWEEN DARKNESS
AND DAWN

Bird on the Wire
Rough Trade
Black Friday
Welcome to My World
Mr Wonderful
Cocktails and Broken Hearts
Night in the City
The Purple Cat
Party People
Dance Me to the End of Love
Weaving the Web
The Altar of Memory
Couple No. 8
The Arrangement

Artist and Model
The Sailor's Toy
Between Darkness and Dawn
Models in the Studio
The Letter
Mr Cool
Wild Thing
Models in the Studio II
Private Dancer
Seven Heaven
The Workstation
Defending Champions
The Wife and the Wine Waiter
Girls' Night
Night Preparations
Only a Rose
The Sailor's Toy (study)
Between Darkness and Dawn (study)
The Very Thought of You
Portrait in Silver and Black
Nail Painting
The Letter (study)

1999
INTERNATIONAL
20TH CENTURY ARTS FAIR

Beautiful Losers
Scarlet Ribbons, Lovely Ribbons
The Assessors
The Tango Master
Self Portrait – Homage to Fontana

Bird on the Wire (study)
Mr Cool (study)
Rough Trade (study)
Another Kind of Love
Heaven on Earth
Lunchtime Lovers
Sweet Little Lies
Suddenly One Summer (study I)
The Truth Discovered
Models in the Studio (study)
A Strange and Tender Magic
Tango Dancers
Mr Wonderful (study)
Suddenly One Summer (study II)
Self Portrait

2000
LOVERS AND OTHER
STRANGERS

Feeding Frenzy
Lunchtime Lovers
An Imperfect Past
Suddenly One Summer
A Strange and Tender Magic II
Union Jack
Valentine Rose
The Assessors II
Queen of the Waltzer
Chemical Comfort
Scarlet Ribbons, Lovely Ribbons II
The Cigar Divan

An Imperfect Past II
Model in White
Under Cover of the Night
At Last, My Lovely
A Terrible Beauty
Beautiful Losers II
Birdy
Self Portrait
My Beautiful Wound
Lines of Sacrifice
Spiders
Cigar Divan II
Silhouette
Suddenly One Summer (study)
Heatwave
The Cocktail Shaker
Under Cover of the Night (study)
Waiting Blonde (study)
Union Jack (study)
The Cigar Divan (study)
Feeding Frenzy (study)
Fetish (study)
At last, My lovely (study)
The Tulip Dress (study)

2001
THE INTERNATIONAL ART
AND DESIGN FAIR

Drifters
Artist in the Studio
Artist and Model

Beautiful Dreamer
Contemplation of Betrayal
Betrayal – The First Kiss
Betrayal – No Turning Back
Model in White
The Blue Gown
Model in Manhattan
The Smooth Operator
Moving On
Model in the Mirror
Evening of Ritual
For My Lover
Model in Westwood
Drifters (study)
Only the Deepest Red I
Only the Deepest Red II
The Blue Gown (study)

2002
ART LONDON
(PAINTINGS 1994-2002)

Queen of Hearts
The Ballroom Spy
Fetish (study)
The Altar of Memory (study)
Night Preparations (study)
The Sailor's Toy
Suddenly One Summer (Study)
Tango Dancers II
The Big Man Arrives (study)
A Strange and Tender Magic (study)

The Smooth Operator (study)
The Green Gown (study)
Model in Westwood (study)
Only the Deepest Red II
A Brave New World (study)
Soho Nights (study)
The Tourist
The Ice Maiden (study)
Model in Black and White (study)
Models in the Studio (study)
Self Portrait

2004
AFFAIRS OF THE HEART

His Favourite Girl
Edinburgh Afternoon
Soho Nights
Pincer Movement
Passion Overflow
Just Another Day
Baby, Bye Bye
Tuesday's Child
The Water Babies
The Runaways
Wicked Games
The Great Poet
Along Came a Spider
Jealous Heart
The Remains of Love
The Set Up
Man At Work

Lucky Seven
The Embrace of the Spider
A Letter of Consequence
Mind Bending
All Systems Go
Man Pursued
An Uninvited Guest
Baby, Bye Bye II
Just Another Day II
A Letter of Consequence II
The Embrace of the Spider II
Self Portrait
Jealous Heart II
Reach Out and Touch
The Runaways II
Along Came a Spider II
All Systems Go II
The Set Up II

INDEX OF PAINTINGS

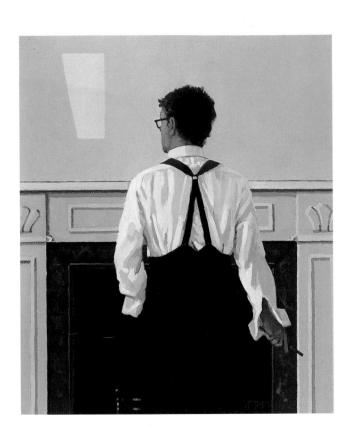